America THE *Beautiful*
CALIFORNIA

DAN LIEBMAN

FIREFLY BOOKS

A Firefly Book

Published by Firefly Books Ltd. 2009

First printing

Publisher Cataloging-in-Publication Data (U.S.)

Liebman, Dan.
 California / Dan Liebman.
[] p. : col. photos. ; cm. America the beautiful series.
Summary: A book of captioned photographs that showcase the natural wonders,
dynamic cities, celebrated history and array of activities of California.
ISBN-13: 978-1-55407-545-4
ISBN-10: 1-55407-545-9
1. California – Pictorial works. I. Title. II. Series.
979.4 dc22 F862.L543 2009

Library and Archives Canada Cataloguing in Publication

California / [captions written by] Dan Liebman.
(America the beautiful)
ISBN-13: 978-1-55407-545-4
ISBN-10: 1-55407-545-9
 1. California--Pictorial works. I. Liebman, Daniel II. Series: America
the beautiful (Richmond Hill, Ont.)
F862.C35 2009 979.4'0540222 C2009-901484-X

Published in the United States by
Firefly Books (U.S.) Inc.
P.O. Box 1338, Ellicott Station
Buffalo, New York 14205

Published in Canada by
Firefly Books Ltd.
66 Leek Crescent
Richmond Hill, Ontario L4B 1H1

Cover and interior design: Kimberley Young

Printed in China

The publisher gratefully acknowledges the financial support for our publishing program
by the Government of Canada through the Book Publishing Industry Development Program.

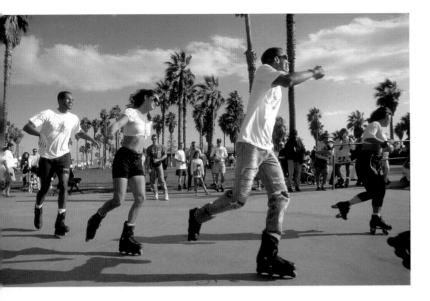

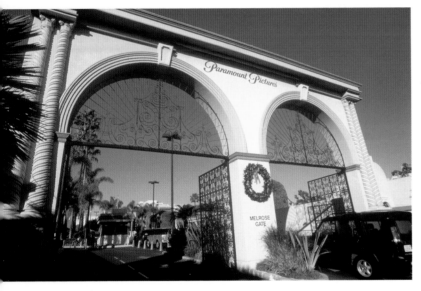

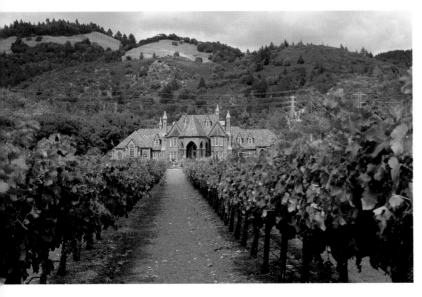

CALIFORNIA'S MOTTO, *Eureka,* translated in English as "I have found it," refers to the discovery of gold in the Sierra Nevada in 1848, but it also echoes the feelings of those who experience this remarkable state.

California is a state of great contrasts. Its highest point, Mount Whitney, is nearly 15,000 feet above sea level, and its lowest, Death Valley, is 282 feet below sea level. Its population of more than 36 million is greater than Canada's, and nearly 10 million people live in Los Angeles County alone. Yet there are enormous stretches of desert and forest that are barely populated.

This book can provide only a sampling of the state's scenic wonders and great cities. Your tour starts in the north, with the majestic beauty of Mount Shasta and Redwood National Park, and ends in the southern desert area, where oases, ancient animals and odd-looking trees seem oblivious to the passage of time. Along the way are detours to some of the state's most important Spanish missions, where much of California's history began.

Moving south, you visit world-famous wineries and lush vineyards. Next is a trip to gold country, with its pioneer history. From there, the journey moves to San Francisco – one of the most beautiful and cosmopolitan cities in the world. A visit to the High Sierras is next, with renowned national parks, crystal clear lakes and snow-capped mountains. A trip down the Pacific coast offers breathtaking vistas. Moving inland, you find the golden sand dunes of Death Valley and the Mojave Desert. The next stop is Los Angeles County – the glamour of Hollywood alongside some unexpected locations – followed by a visit to Orange County and the magic of Disneyland. Next on the tour is San Diego County, with scenic coves and a remarkable zoo.

From the grandeur of its parks to the stark beauty of its deserts, from spectacular coastal scenery to fertile vineyards, and from cosmopolitan cities to lively coastal towns, the state offers an abundance of treasures. We hope you'll enjoy them as you travel the pages of *America the Beautiful – California.*

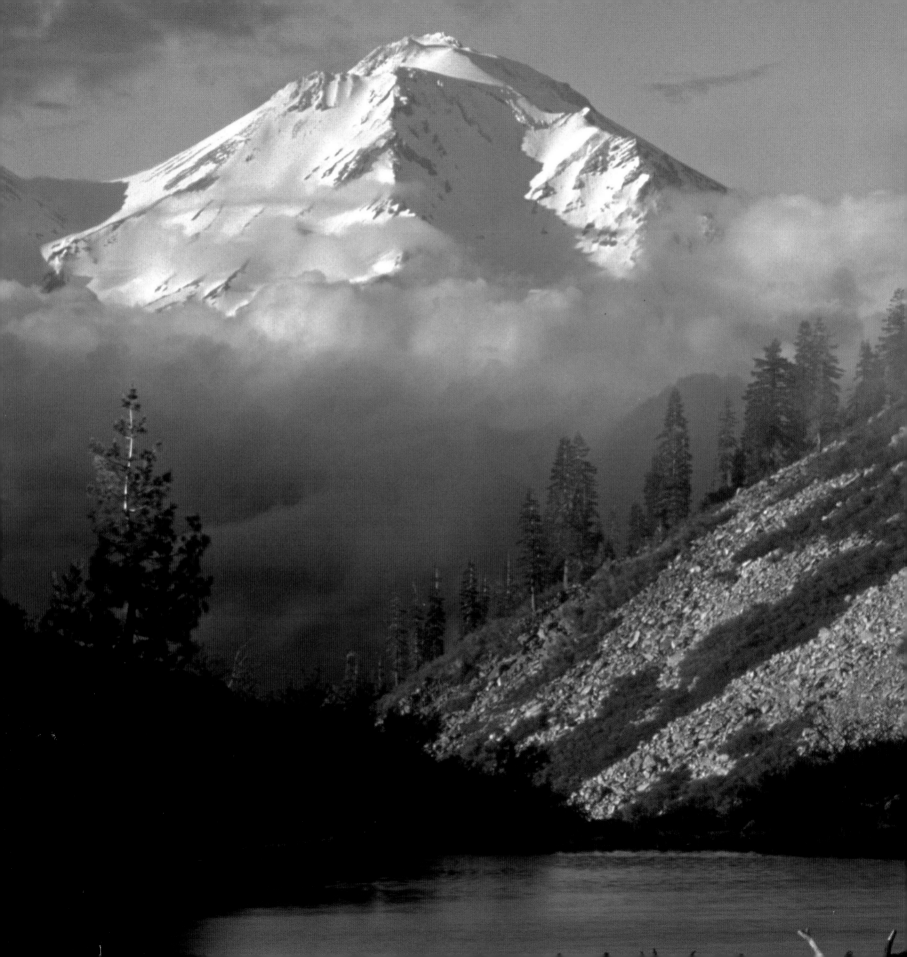

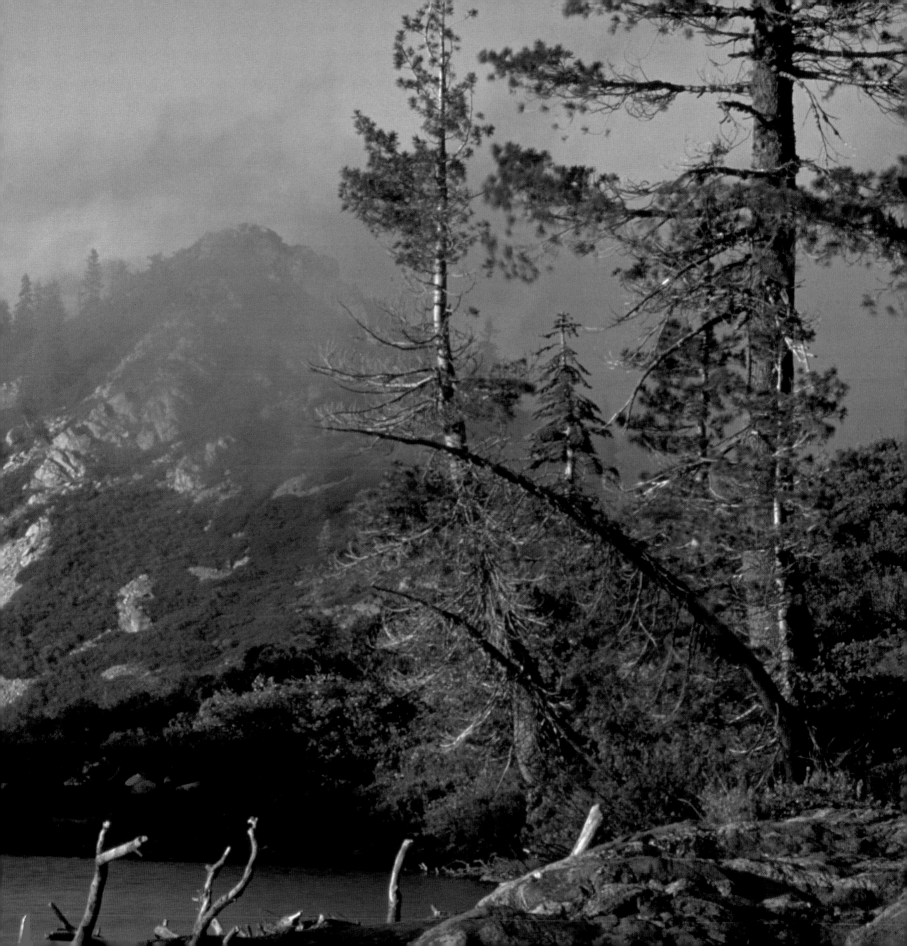

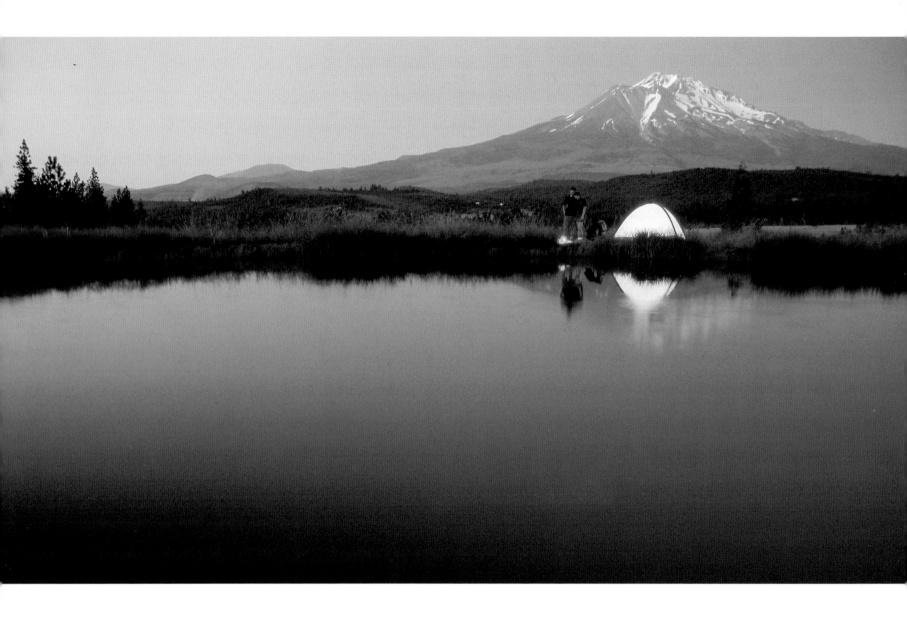

ABOVE: Shasta-Trinity National Forest is a favorite location among campers. It encompasses five wilderness areas and hundreds of mountain lakes.

OPPOSITE PAGE: The sun's rays break through the majestic trees of Redwood National Park. The coniferous Coast Redwood, which reaches over 350 feet, is the tallest tree species on the planet. The highest known redwood is 379 feet. To protect the tree, the park's rangers don't reveal its location.

PREVIOUS PAGE: Heart Lake, with the snow-capped Mount Shasta in the background. Mount Shasta, in Northern California's Shasta-Trinity National Forest, reaches a height of over 14,000 feet and is visible from a distance of more than a hundred miles. The mountain is a dormant volcano with five living glaciers.

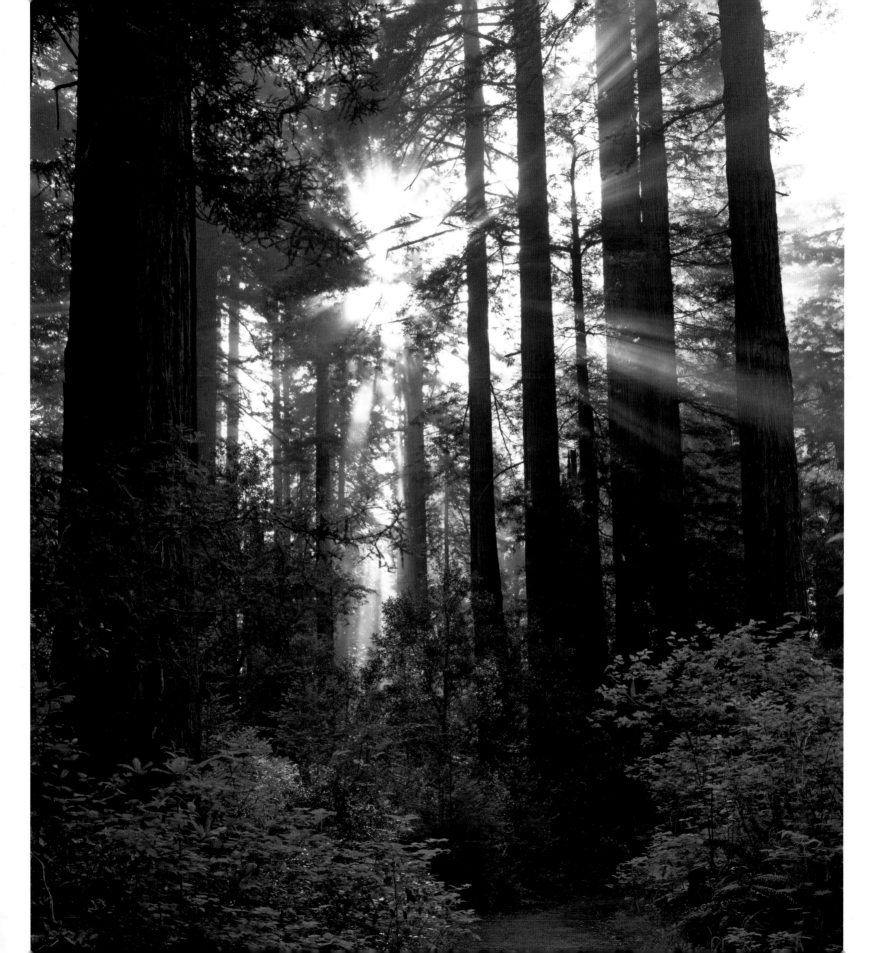

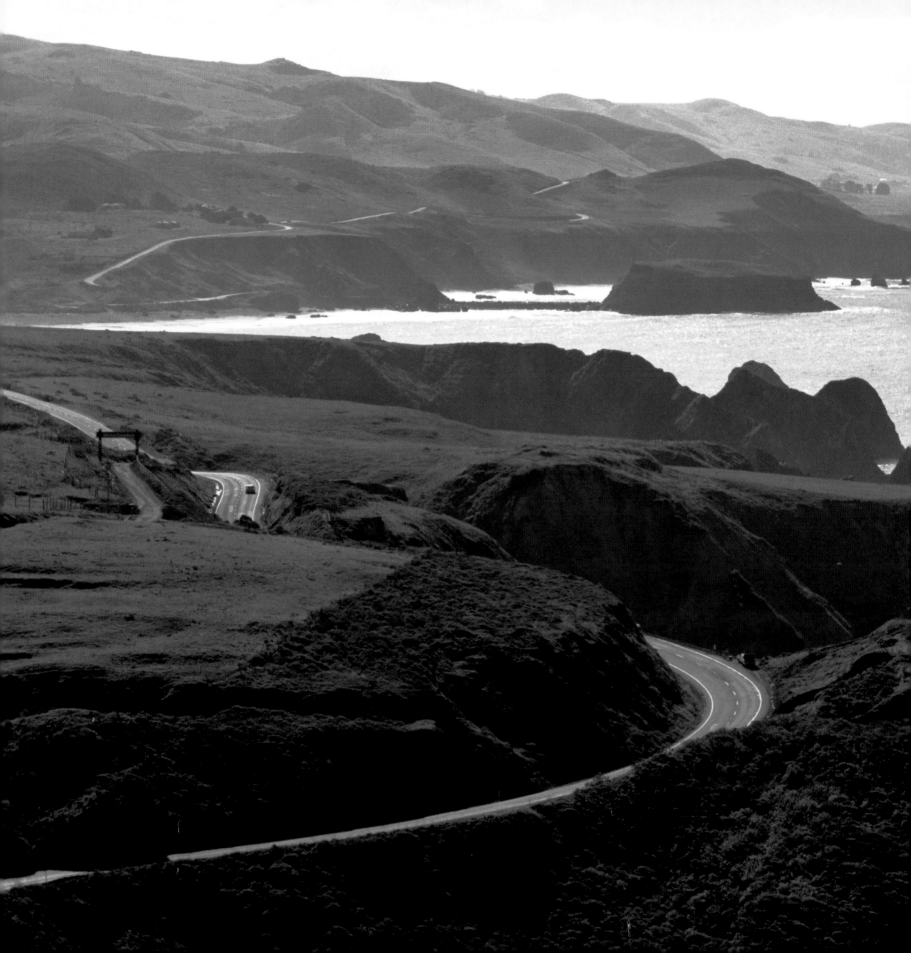

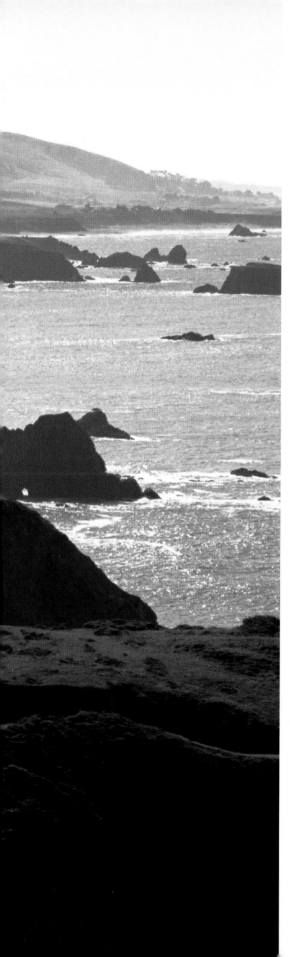

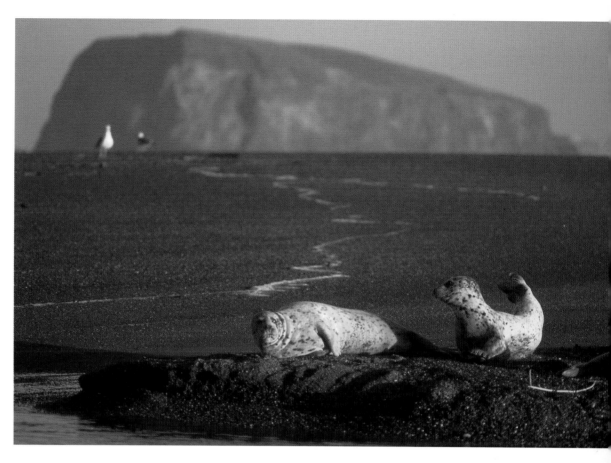

ABOVE: Sonoma County's seals and birds compete for fish where the Russian River meets the Pacific Ocean.

OPPOSITE PAGE: Sonoma County offers sandy beaches and a craggy coastline, along with celebrated wineries.

FOLLOWING PAGE: This hillside vineyard is nestled in the Napa Valley, one of California's most famous wine-producing regions. The fertile valley features over 300 wineries and grows numerous grape varieties, including Cabernet Sauvignon, Chardonnay, Merlot and Zinfandel.

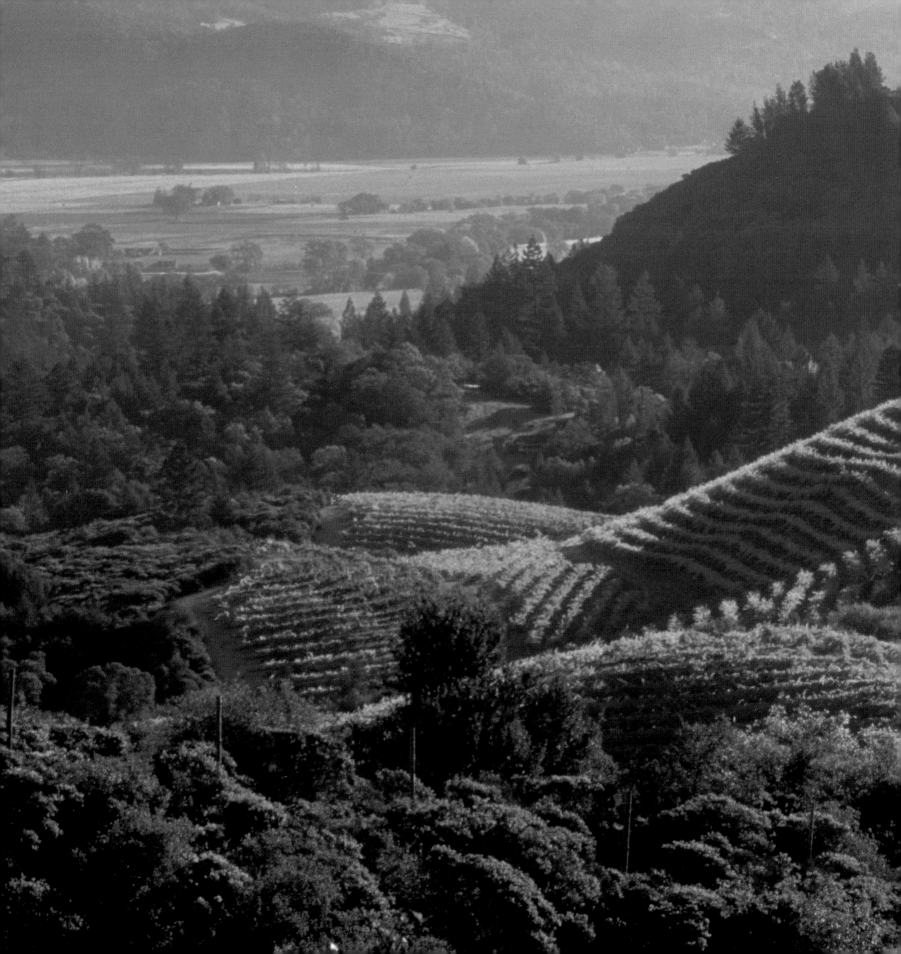

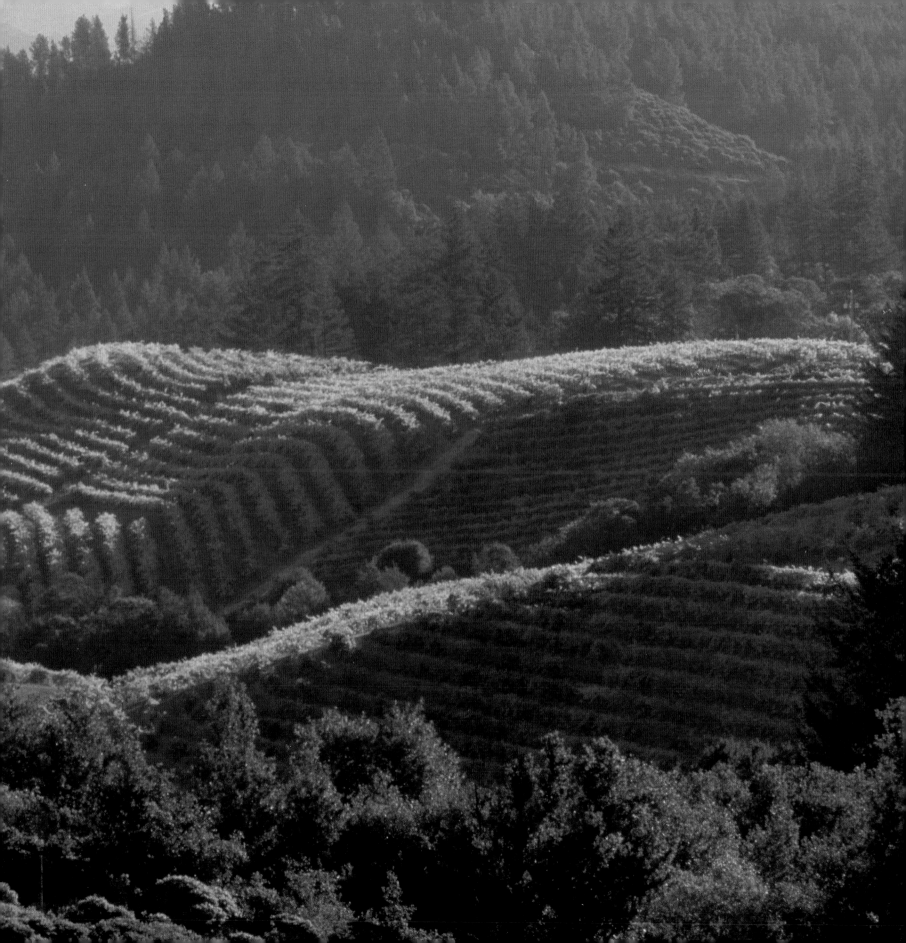

Mission San Francisco Solano was founded on July 4, 1823, and is the northernmost of California's chain of 21 missions. Over the years it has seen many different uses, including a saloon. Today, it is part of Sonoma State Historic Park.

OPPOSITE PAGE: Almost half of California's wineries are located in Napa and Sonoma counties, within a hundred miles of San Francisco. Among the most popular is the opulent Ledson Winery, popularly known as "the castle."

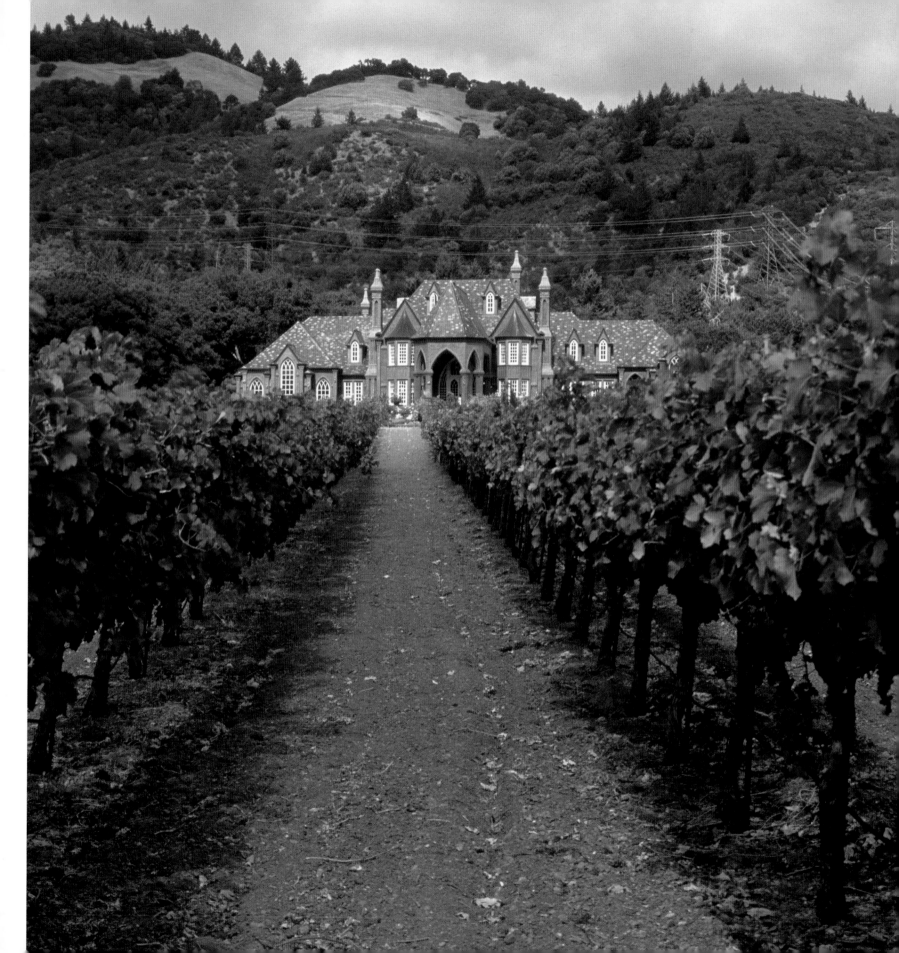

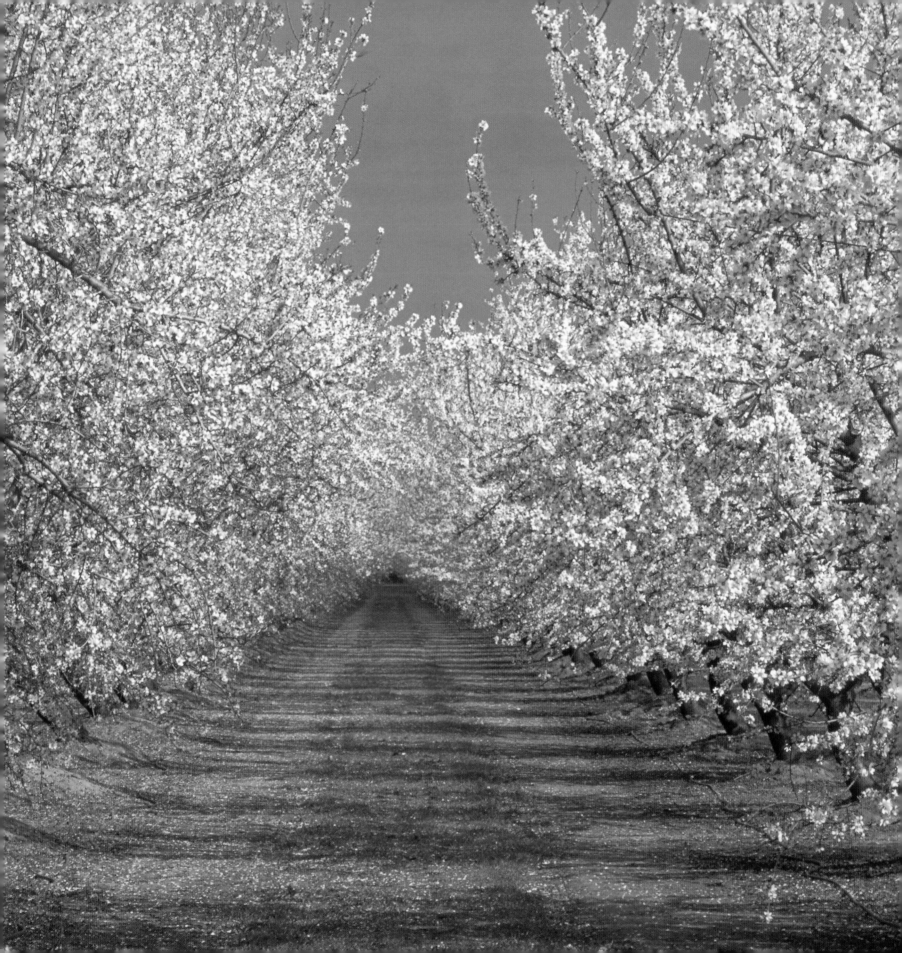

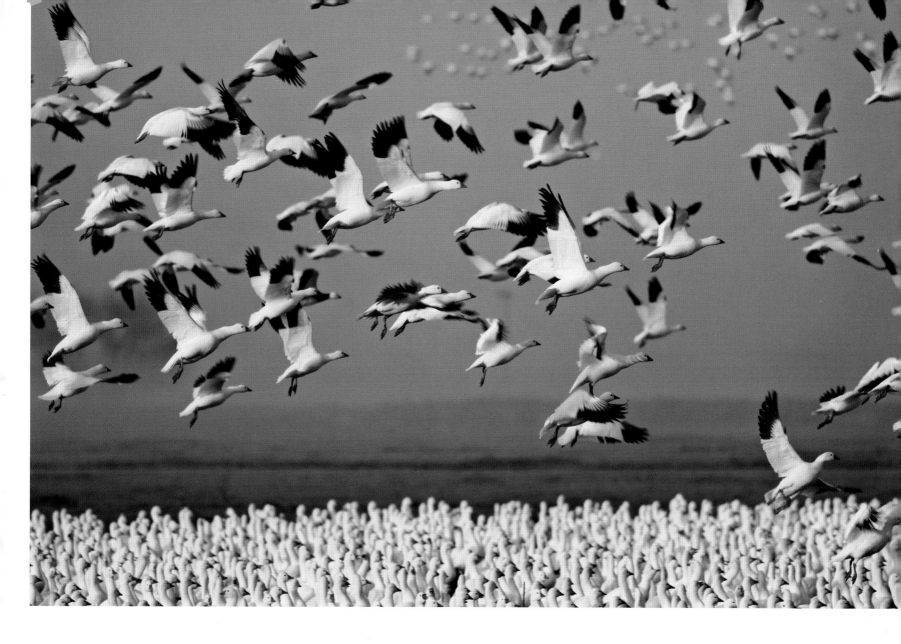

Migrating Ross's Geese along the California Pacific Flyway at the Merced National Wildlife Refuge. Up to a hundred thousand geese of various species are attracted to the refuge between November and March.

OPPOSITE PAGE: The willowy branches and delicate flowers of almond trees grace a grove in Modesto, in the northern San Joaquin Valley near the geographic center of California. California produces 80 percent of the world's almonds, the state's number one agricultural export.

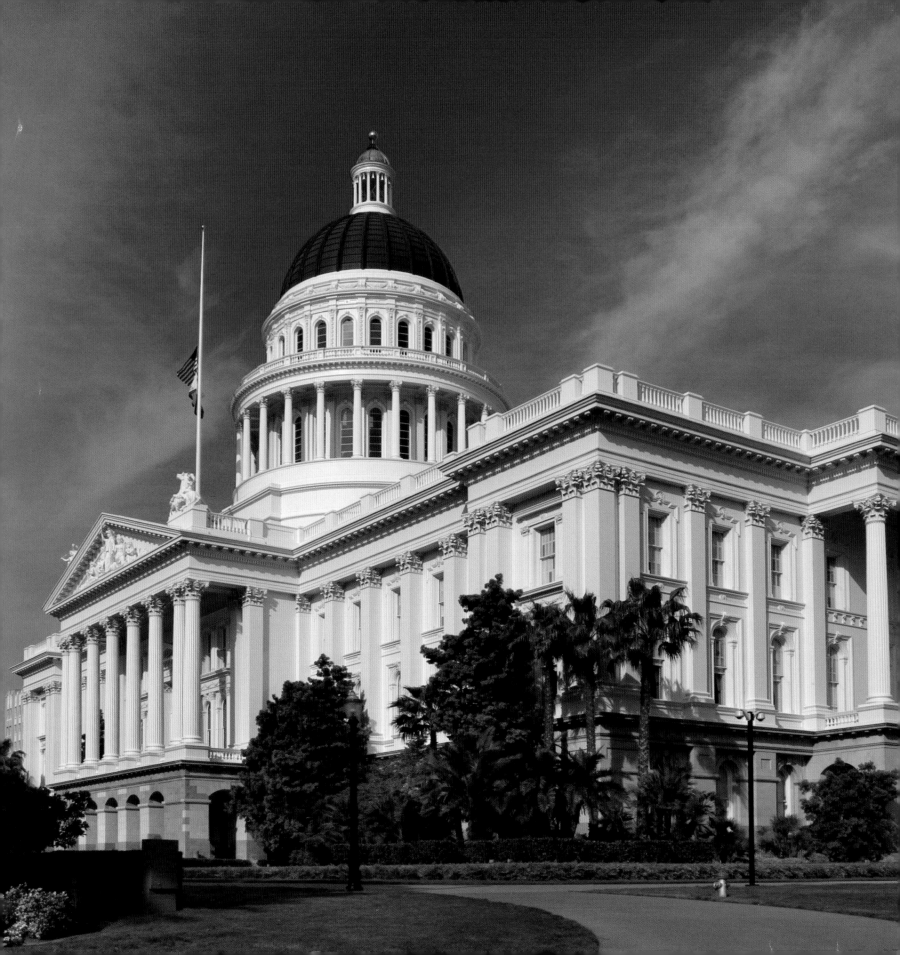

Replica of Sutter's Mill, Marshall Gold Discovery State Historic Park. It was near this location that James W. Marshall discovered gold in 1848. The discovery led to the Gold Rush, which sparked the growth of the West in the years that followed.

OPPOSITE PAGE: The California State Capitol building in Sacramento houses the California State Legislature and the Office of the Governor. The building, constructed between 1861 and 1874, is based on the Capitol in Washington DC. During the Gold Rush, Sacramento was a terminus for wagon trains, stagecoaches, riverboats, the Pony Express and the transcontinental railroad.

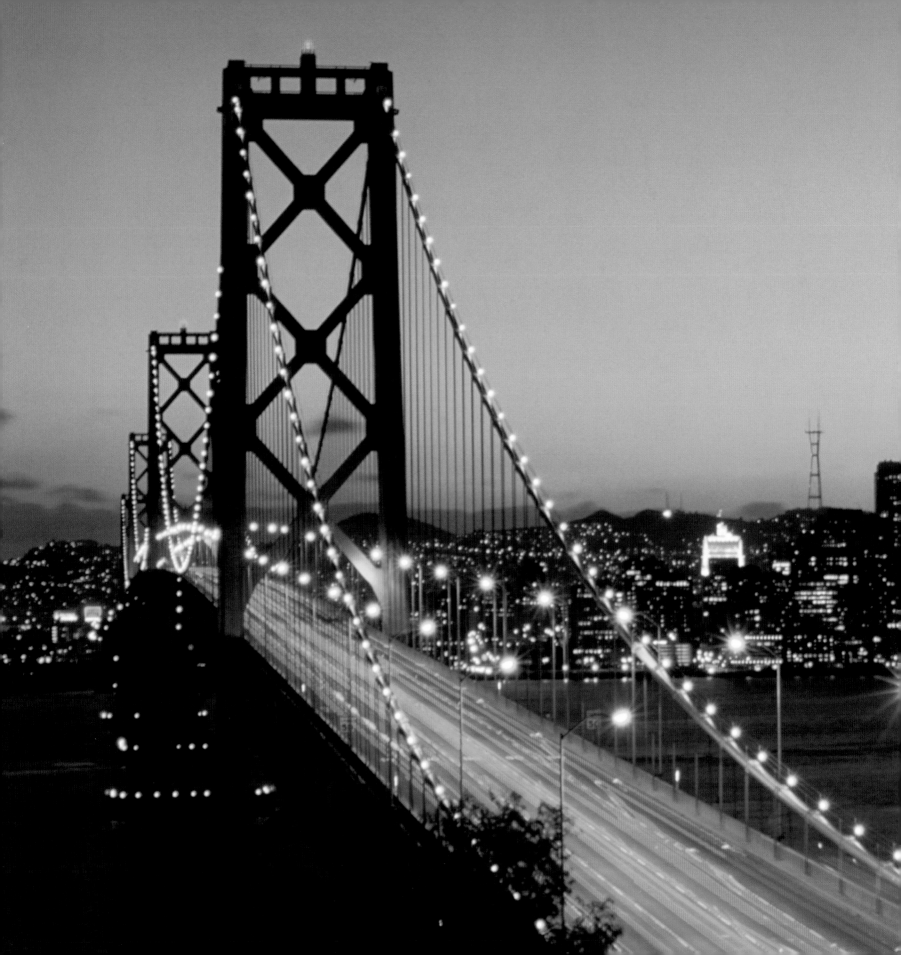

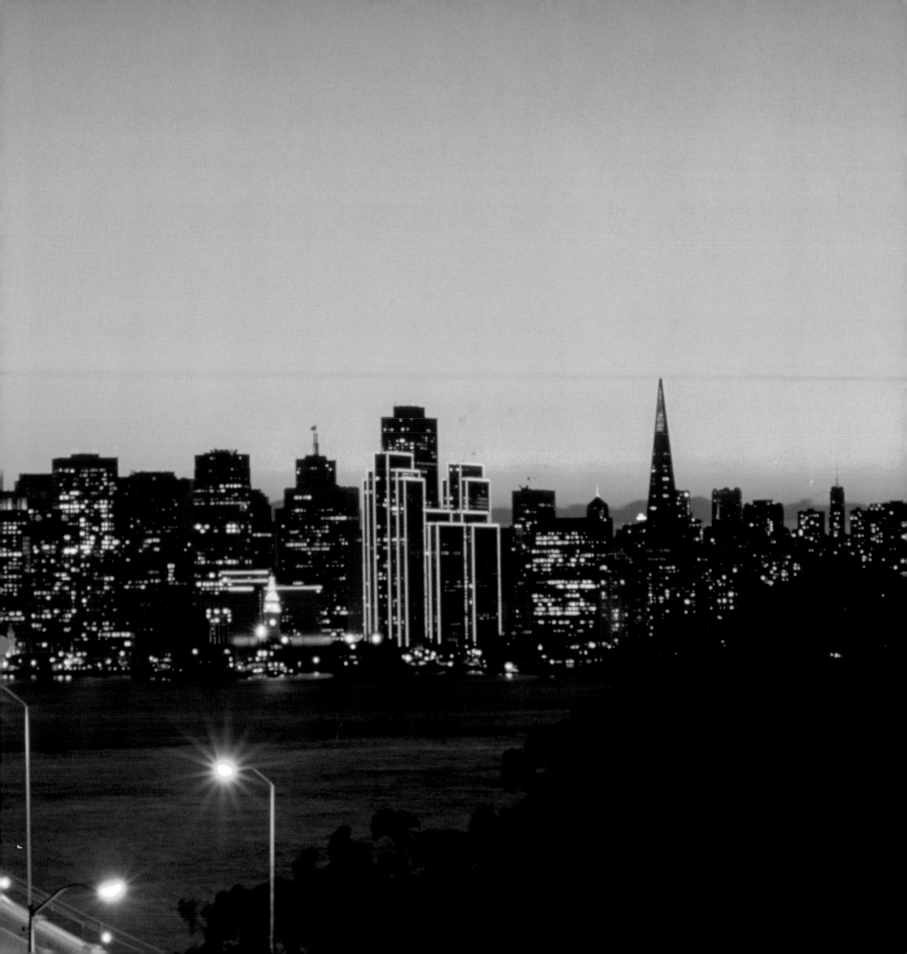

The missions along California's El Camino Real (the Royal Highway) represent the first arrival of non-Native Americans to the state. Mission Dolores is the oldest intact building in the City of San Francisco. It opened in 1776 and has witnessed more than two centuries of history, including the 1848 Gold Rush and the earthquake of 1906.

OPPOSITE PAGE: Coit Tower lights up Telegraph Hill, one of the most charming areas of the city. The Art Deco tower was bequeathed to the city by Lillie Hitchcock Coit, an eccentric philanthropist.

PREVIOUS PAGE: The San Francisco–Oakland Bay Bridge, locally called the Bay Bridge, spans San Francisco Bay. Considered one of the engineering wonders of the modern world, the bridge, along with the illuminated towers of San Francisco and the sky at dusk, provides a brilliant light show.

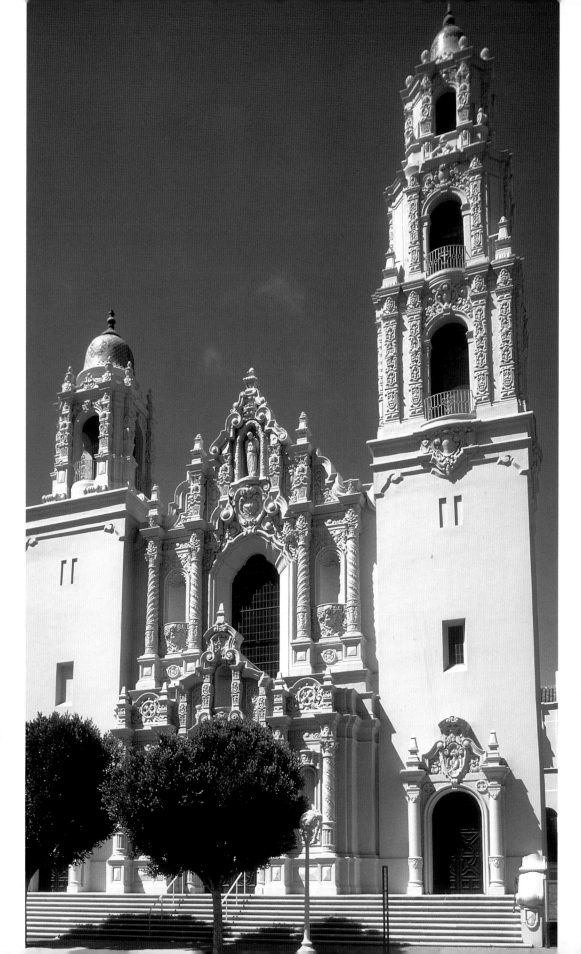

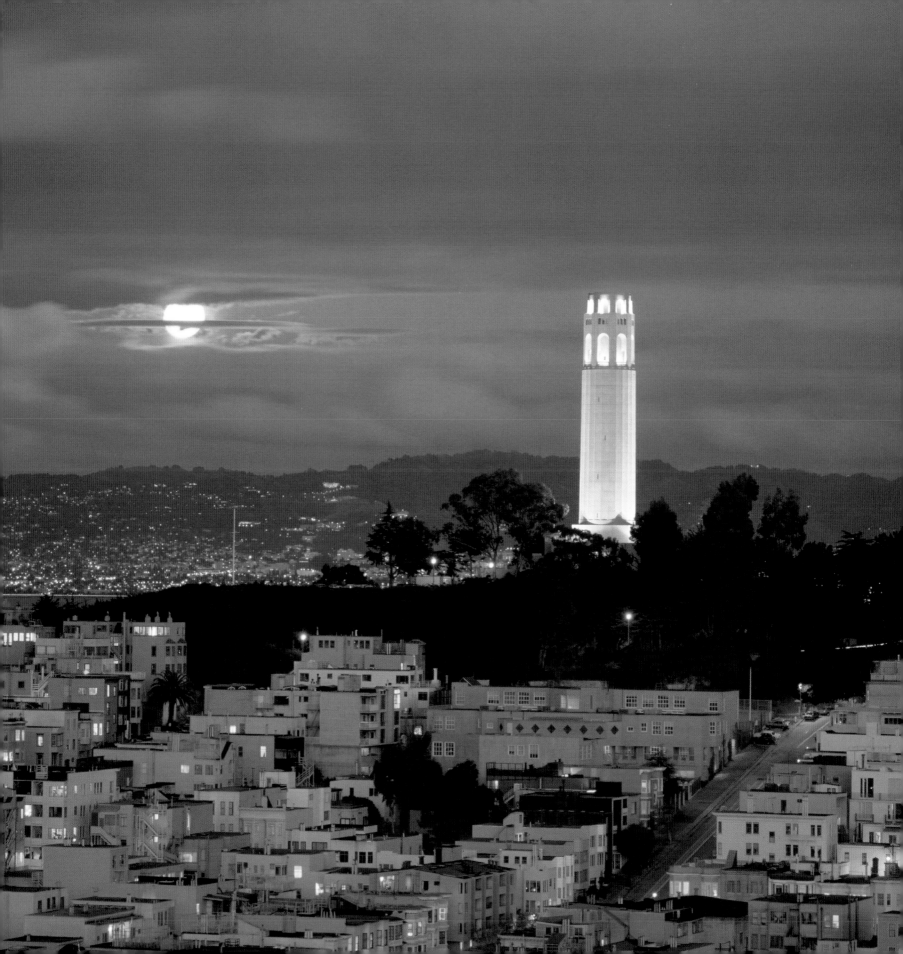

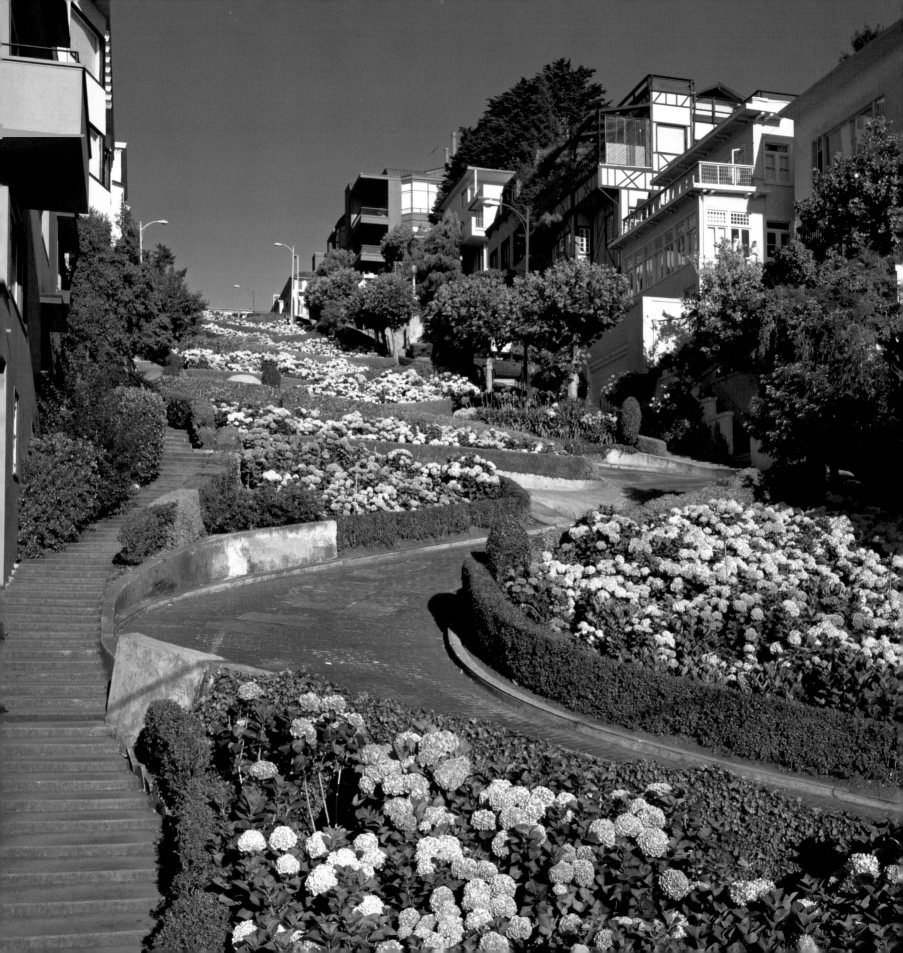

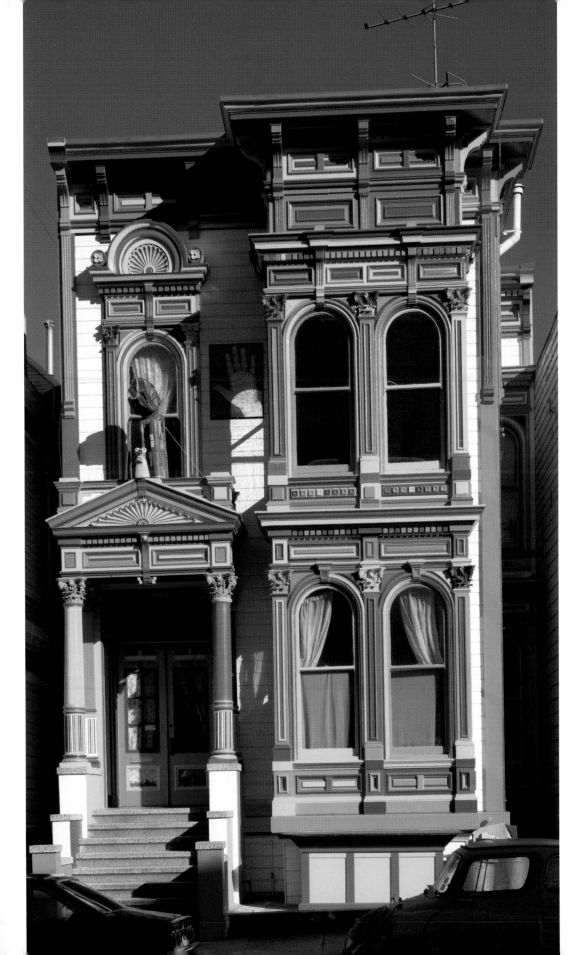

Brightly colored Victorian homes are a San Francisco trademark. The tradition of painting houses in rainbow hues began after the Civil War. The buildings are affectionately referred to as "painted ladies."

OPPOSITE PAGE: San Francisco's Lombard Street is famous for its steep section of eight sharp turns, which have earned it the distinction of being the "crookedest street in the world." (Some say that it's the second crookedest – after Wall Street.)

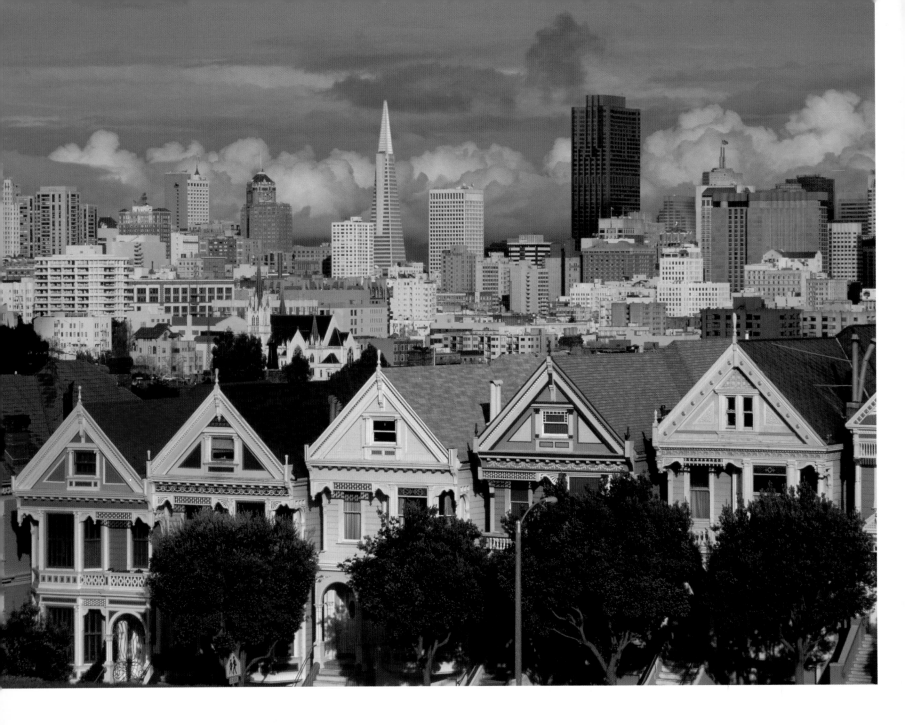

Alamo Square overlooks downtown San Francisco. The most prominent building in the background is the 48-story Transamerica Pyramid, the tallest skyscraper in the city.

OPPOSITE PAGE: The Palace of Fine Arts is located in San Francisco's Marina District. Originally constructed for the 1915 Panama-Pacific Exposition, the elegant setting is a favorite wedding location throughout the Bay Area.

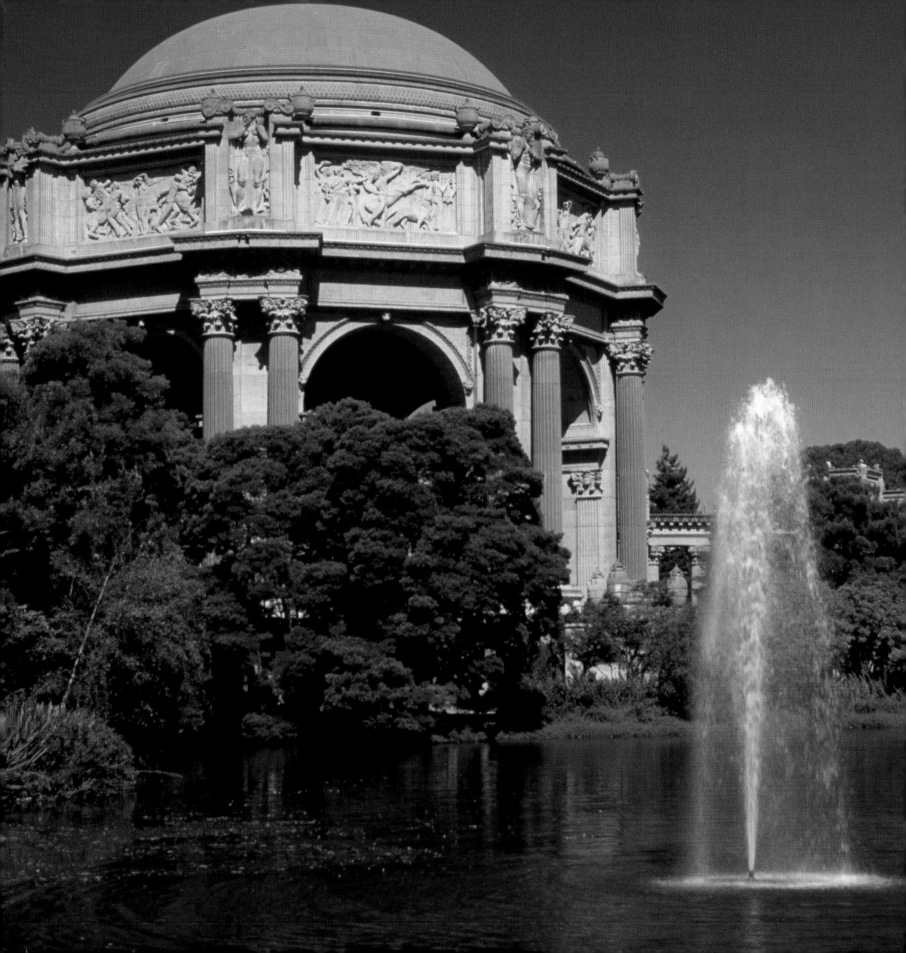

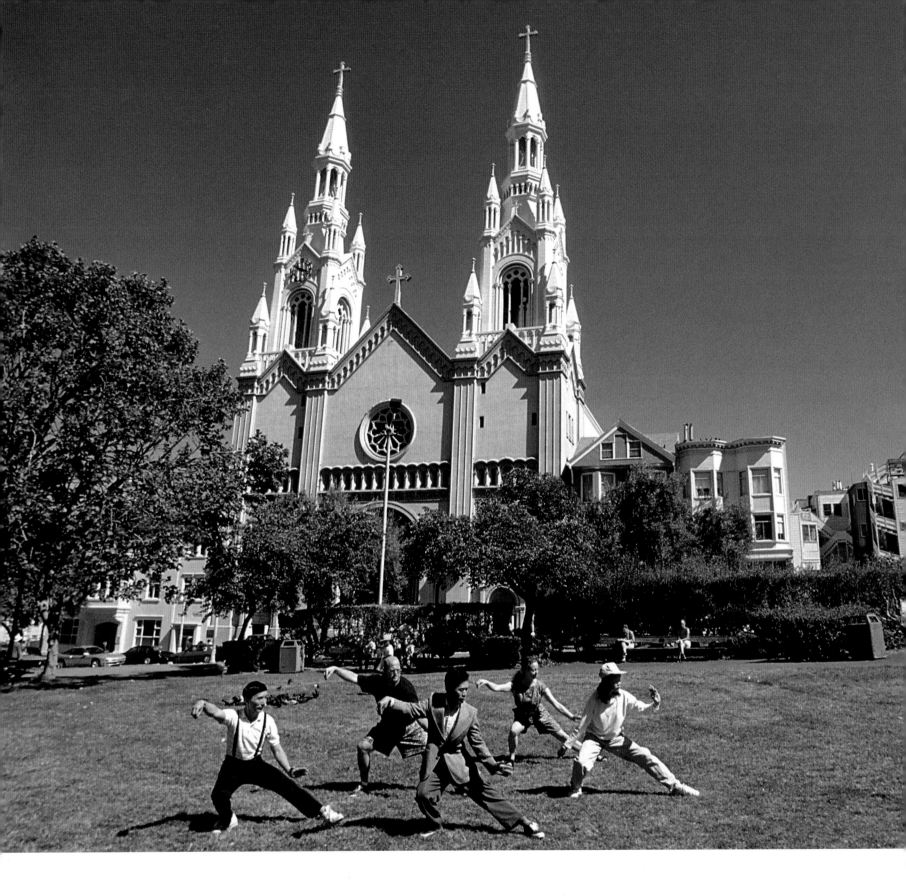

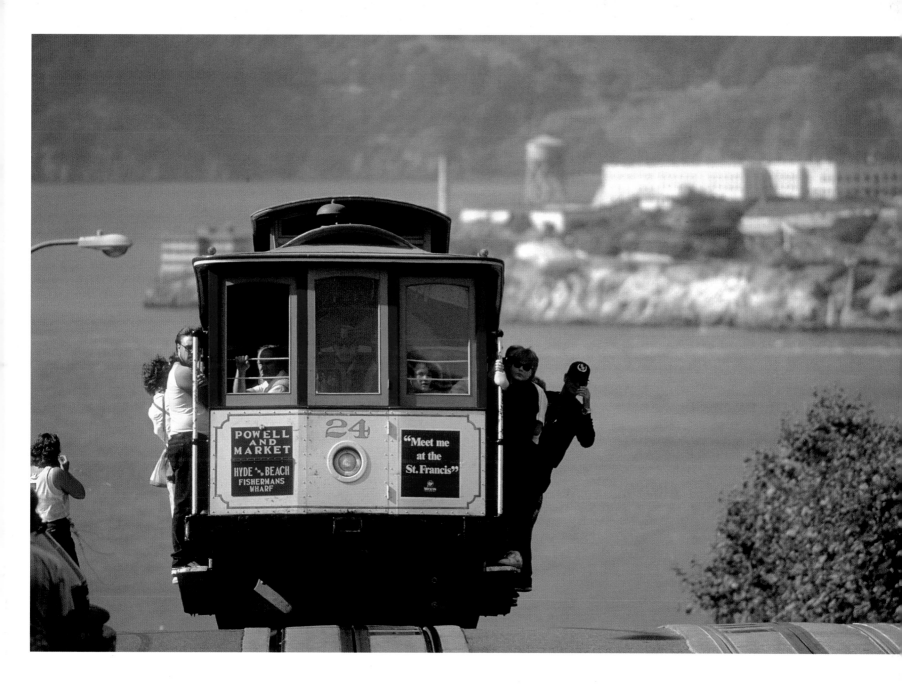

The cable car defines San Francisco. There are several cable car routes, and the system serves both commuters and tourists – who say it's the most fun way to get up and down in this city of hills.

OPPOSITE PAGE: Washington Square Park is an urban oasis in the city's lively North Beach neighborhood. Saints Peter and Paul Church sits across from the park, which has survived thanks to the efforts of area residents. Restaurants and cafés fill the surrounding streets.

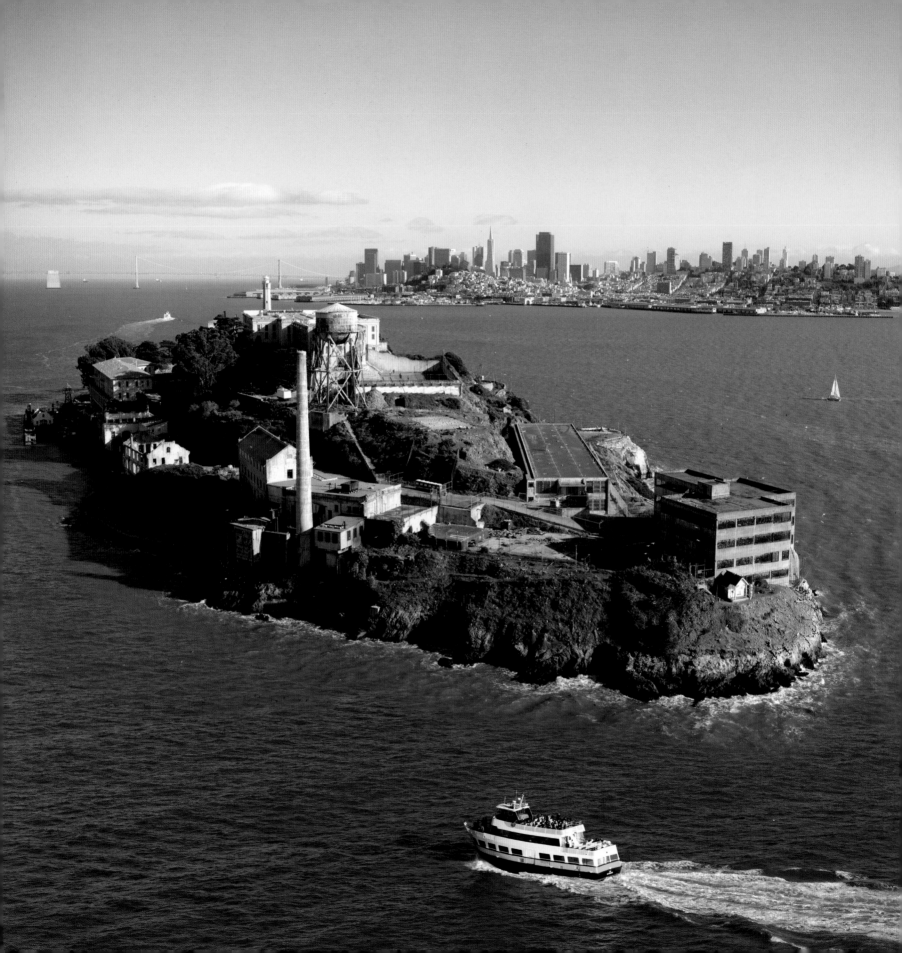

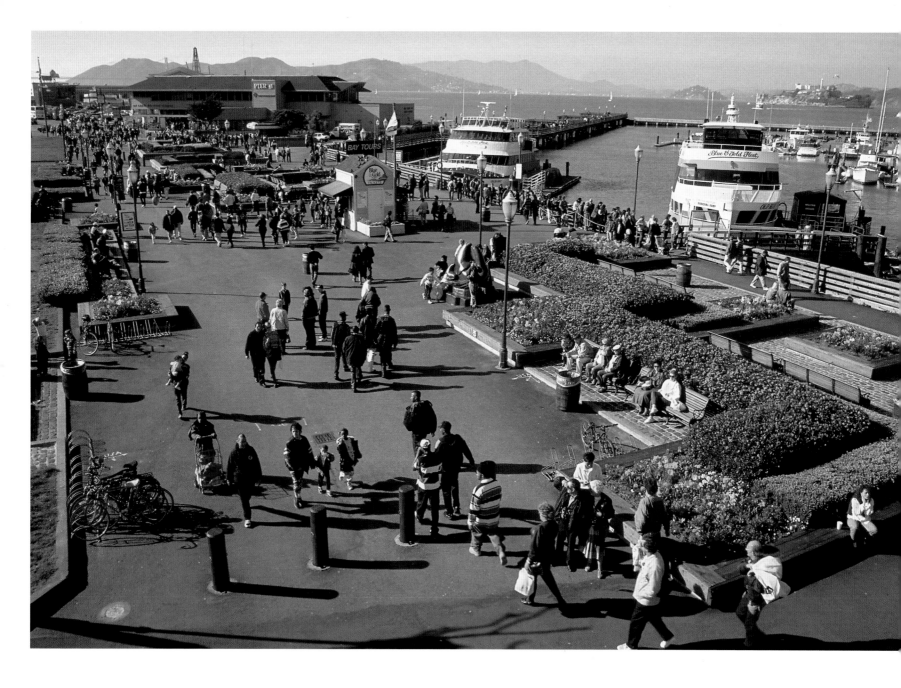

Pier 39 is located at the edge of Fisherman's Wharf and is one of San Francisco's most popular attractions. Street performers, restaurants, shops and a marina – offering views of California sea lions – are all part of the lively scene.

OPPOSITE PAGE: Alcatraz Island, commonly referred to as The Rock, served as a lighthouse, a military fortification, a military prison and, most infamously, a federal prison. Visitors can reach this historic site by ferry from Pier 33.

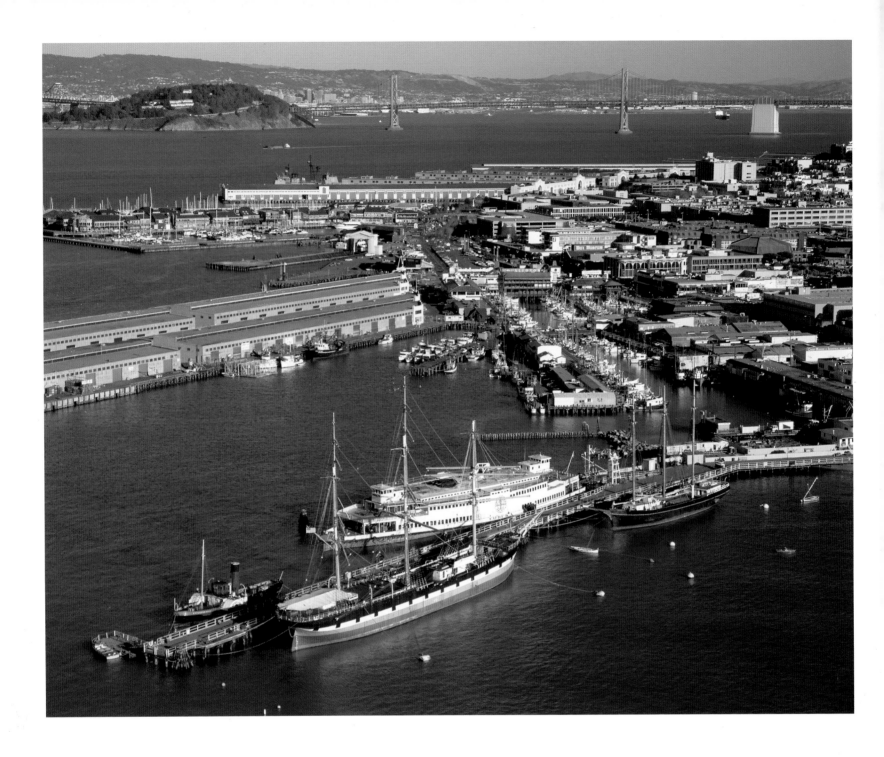

ABOVE & OPPOSITE PAGE: Fisherman's Wharf is one of San Francisco's most popular tourist attractions. It offers restaurants, shops, markets, cruises and shows by street performers. Some of the restaurants have been operated by the same family for three generations, and many are famous for fresh seafood dishes and the local sourdough bread.

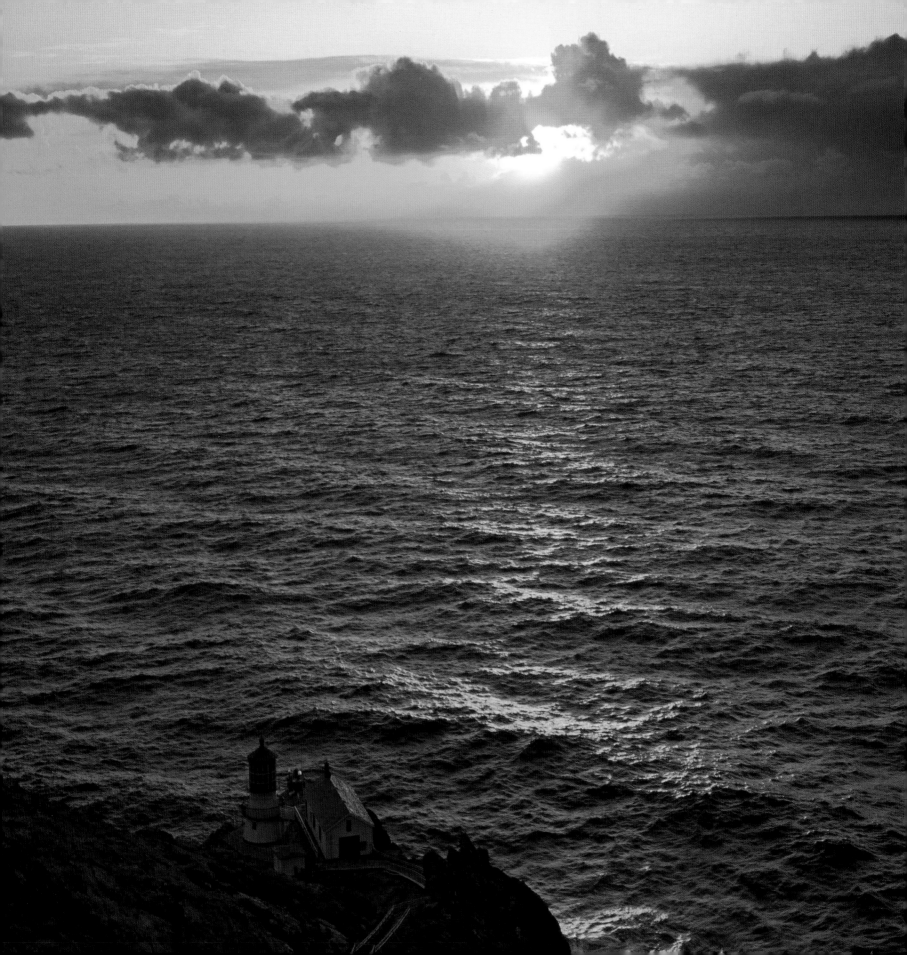

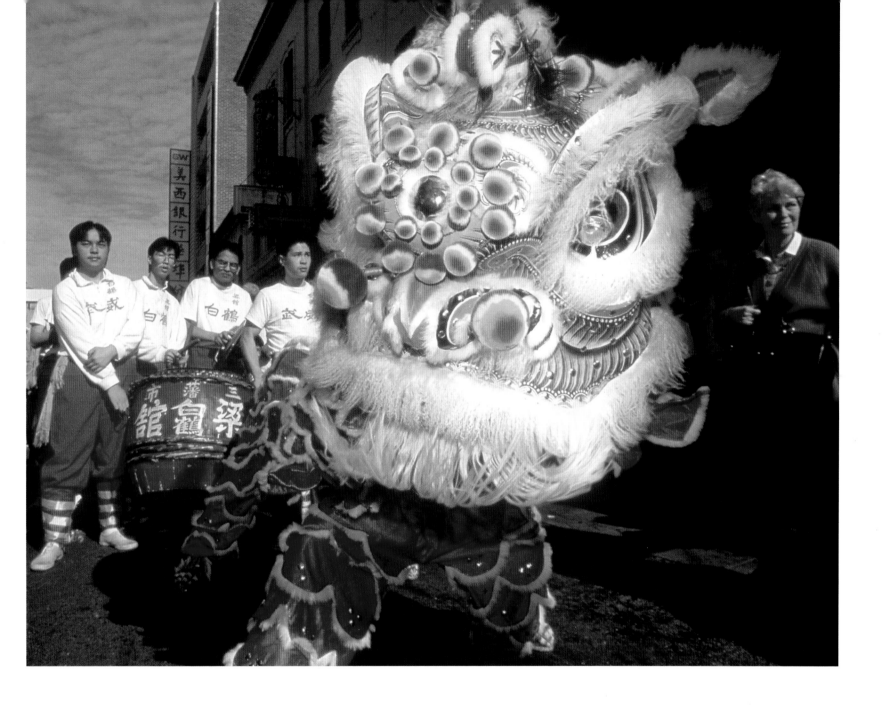

San Francisco's Chinatown is the oldest Chinatown in North America. Its major thoroughfare is Grant Avenue, packed with colorful stores, popular restaurants and souvenir shops – and the location of the annual Chinese Lunar New Year parade.

OPPOSITE PAGE: Point Reyes in Marin County, across the Golden Gate Bridge and about 30 miles outside San Francisco, is said to be the windiest place on the Pacific coast. The Point Reyes Lighthouse, no longer in use, was built in 1870.

The Japanese Tea Garden is a popular spot in Golden Gate Park. The landscaped grounds feature beautiful gates, monuments and statues, as well as a teahouse that overlooks a tranquil water garden.

OPPOSITE PAGE: The Golden Gate Bridge connects San Francisco to Marin County and the Redwood Highway. When it was completed in 1937, it was the world's longest suspension bridge. Although that title no longer holds, the Golden Gate is an internationally recognized symbol of both the city and the state.

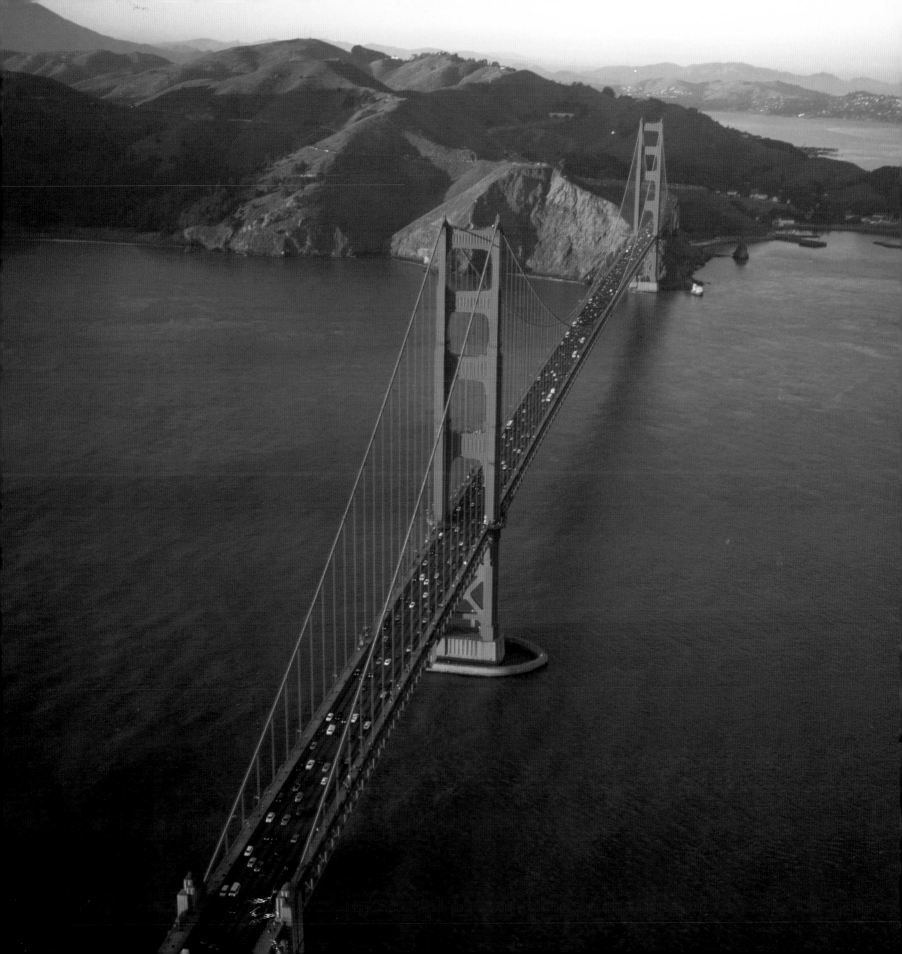

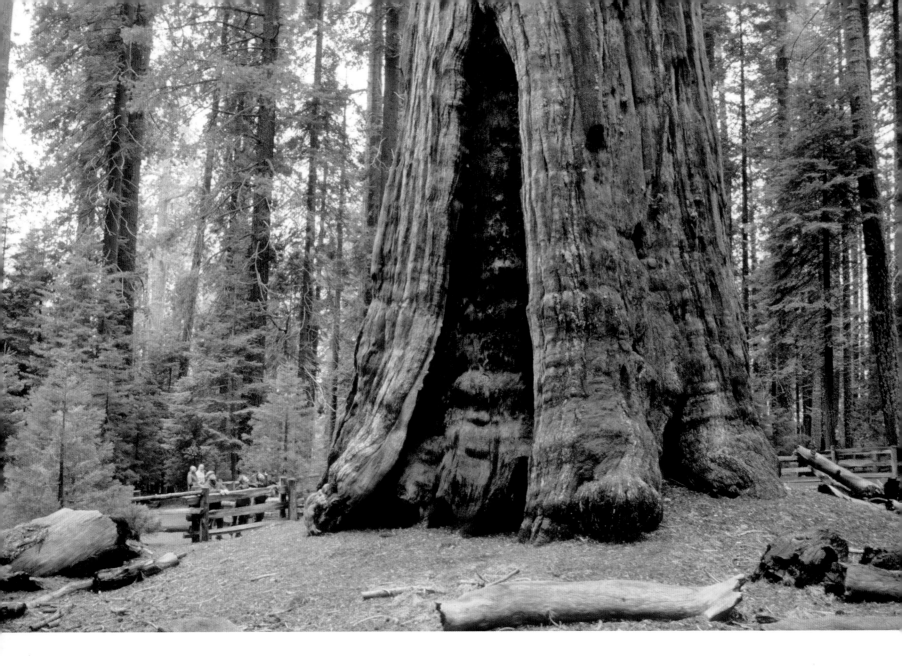

The General Sherman Tree, seen here, is said to be the largest in the world, as measured by the volume of wood (52,500 cubic feet). The tree is approximately 2,200 years old and is located in the Giant Forest of Sequoia National Park.

OPPOSITE PAGE: Mono Lake, believed to be at least one million years old, covers about 65 square miles. The lake's strange tufa towers are actually spires and knobs that develop when freshwater springs mix with the alkaline water of an inland salt lake.

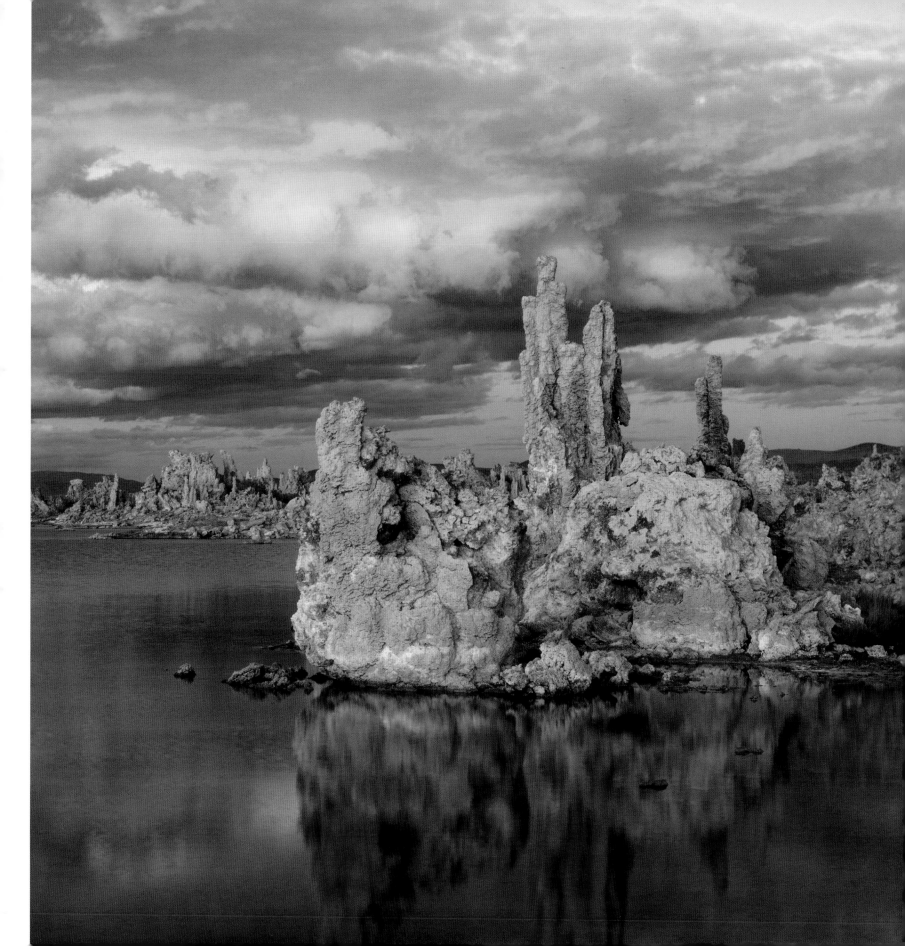

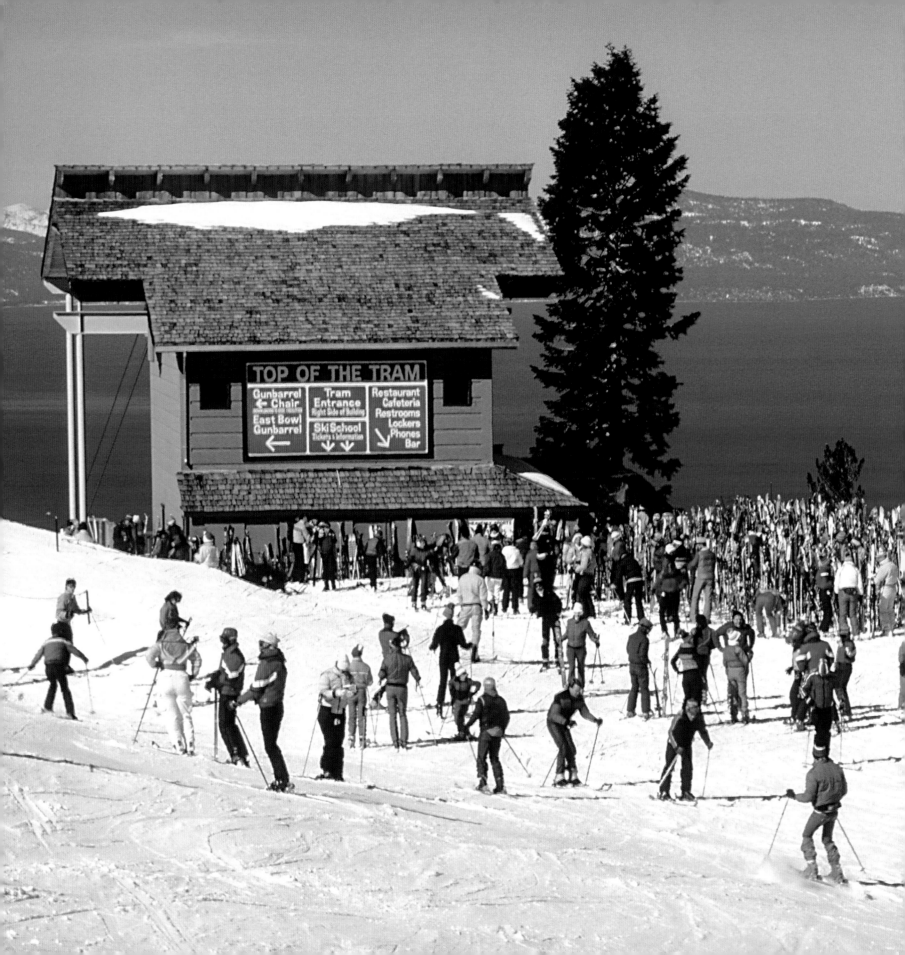

TOP OF THE TRAM

Gunbarrel
← Chair

East Bowl
Gunbarrel
←

Tram
Entrance
Right Side of Building

Ski School
Tickets & Information
↓

Restaurant
Cafeteria
Restrooms
Lockers
Phones
Bar
↓

Lake Tahoe, known as the "lake in the sky," is North America's largest alpine lake. The peaks surrounding Lake Tahoe include several internationally famous ski resorts. Heavenly Valley (left) is the largest among them. Squaw Valley (above), the second largest, was the site of the 1960 Winter Olympics.

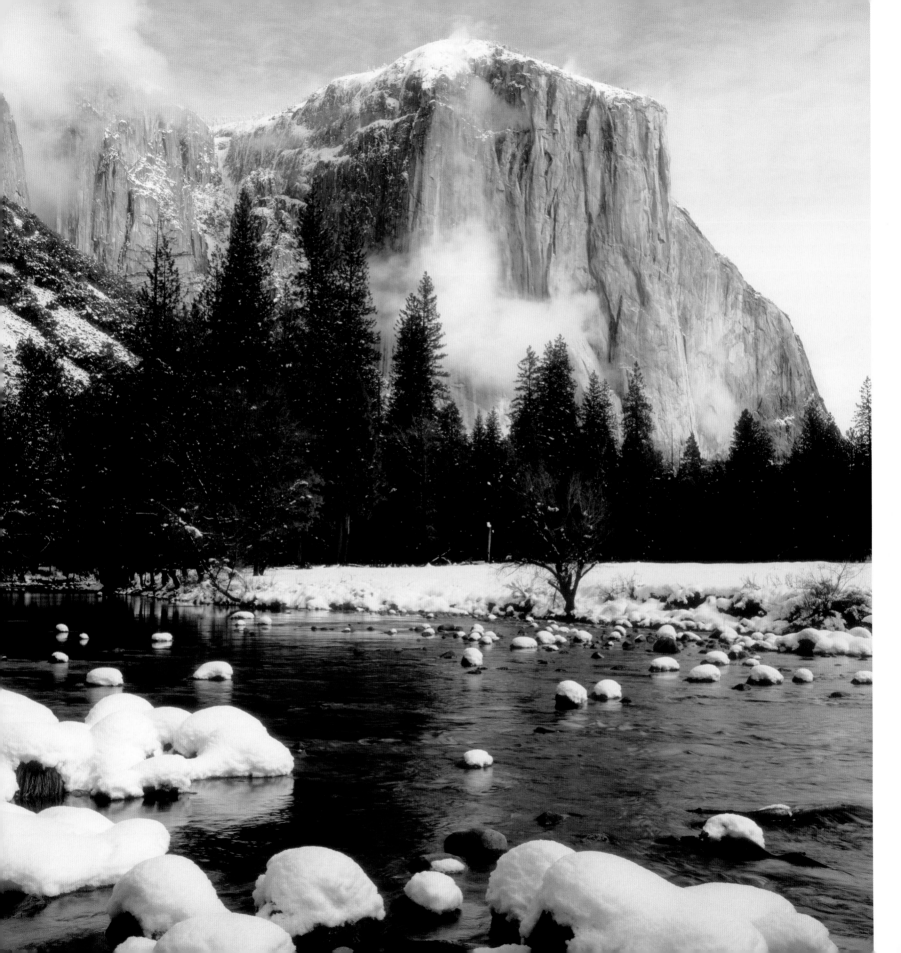

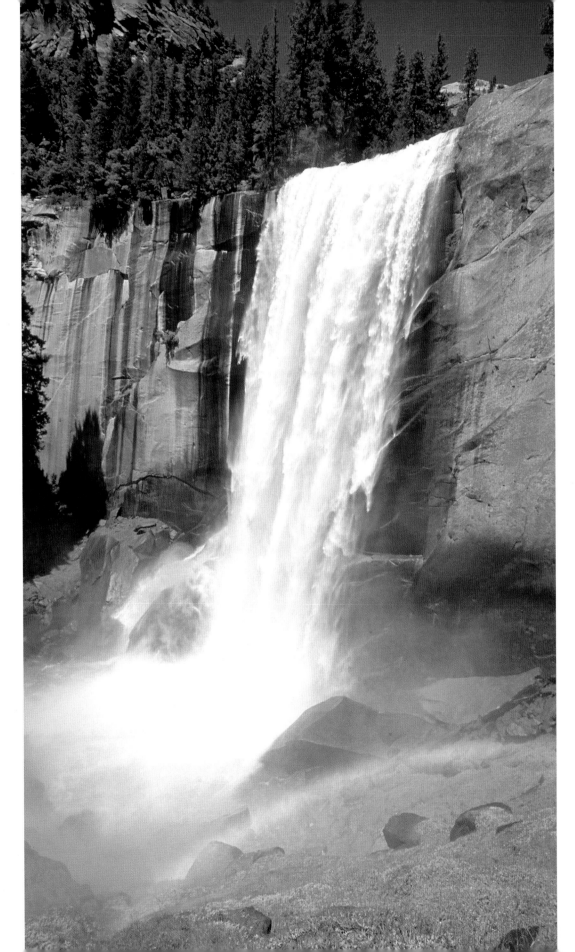

Yosemite's Vernal Fall drops 317 feet and is one of the many powerful waterfalls within the park. Hikers can travel through the fall's mist, along a route called the Mist Trail.

OPPOSITE PAGE: Yosemite National Park was established in 1890, and people travel from around the world to see its wonders. El Capitán stands majestically behind the Merced River. Rising three thousand feet, it is the world's largest monolith of granite.

FOLLOWING PAGE: Beautiful springtime wildflowers bring a riot of color to McGee Creek Canyon in the Eastern Sierra Mountains. Surrounded by dramatic peaks, the canyon is a favorite place for photographers and nature lovers.

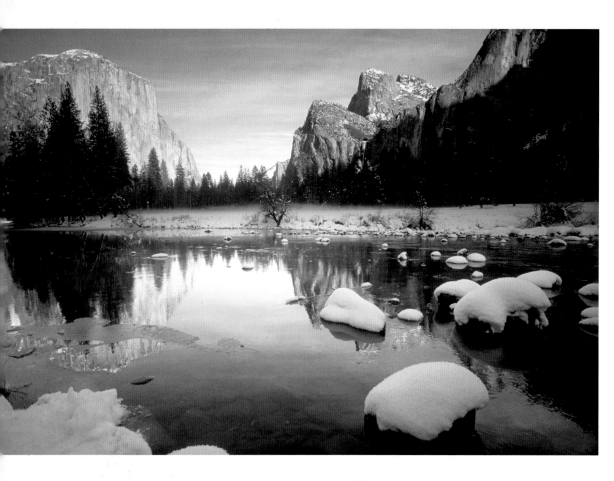

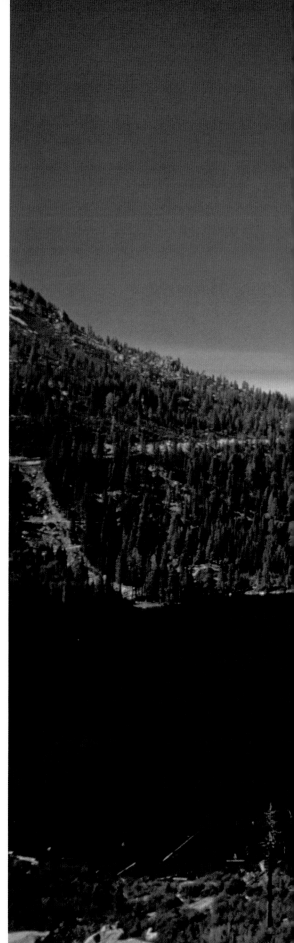

This picturesque scene is known as Gates of the Valley (or Valley View). El Capitán and Cathedral Rocks, which provide the gates, are reflected in the Merced River.

OPPOSITE PAGE: Emerald Bay State Park contains the only island in Lake Tahoe. As well as being remarkably clear and deep blue, Lake Tahoe's waters are said to be 97 percent pure.

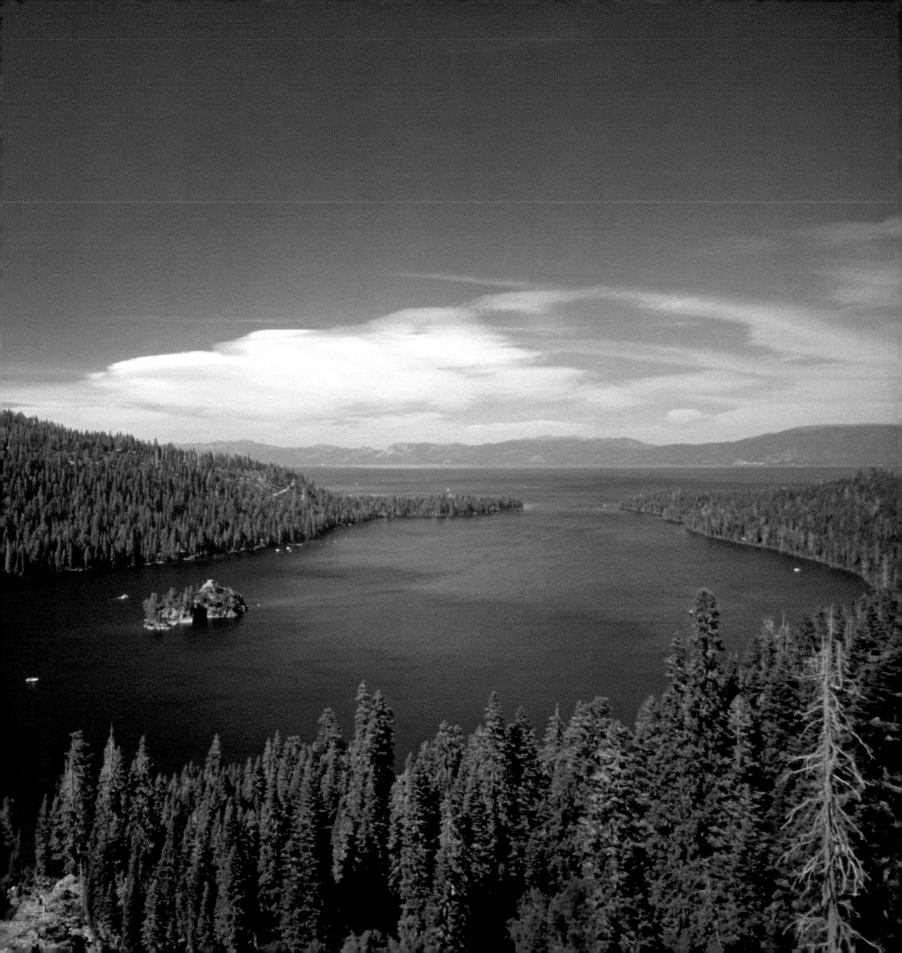

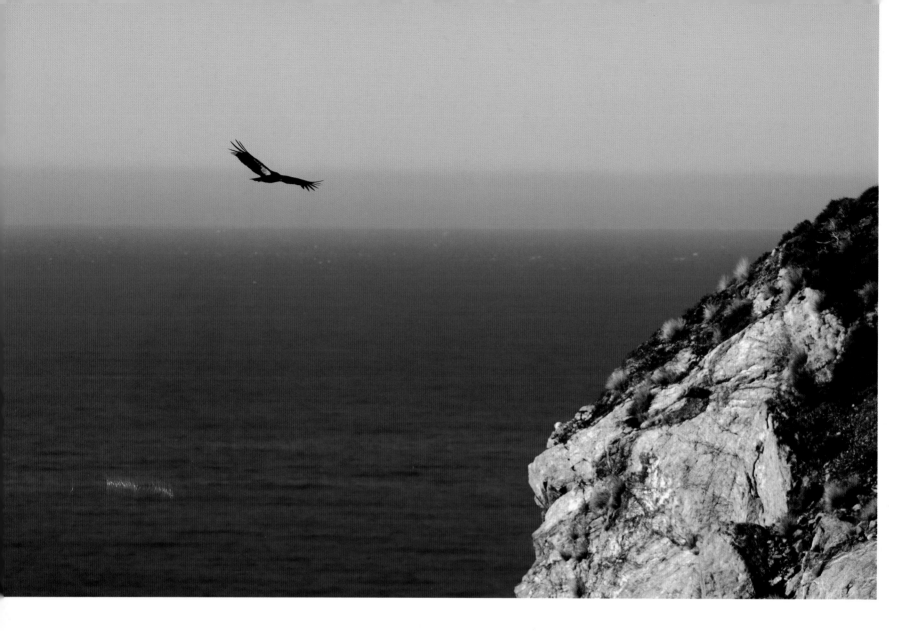

The endangered California condor soars over the Big Sur coast and the Pacific. This is North America's largest land bird, important in Native American mythology and one of the world's rarest bird species.

OPPOSITE PAGE: Bixby Creek Bridge in Big Sur is located 13 miles south of Carmel. Before it was completed in 1932, a short return trip between Monterey and the Big Sur Valley could take as long as three days. The bridge is one of the most photographed places on the west coast.

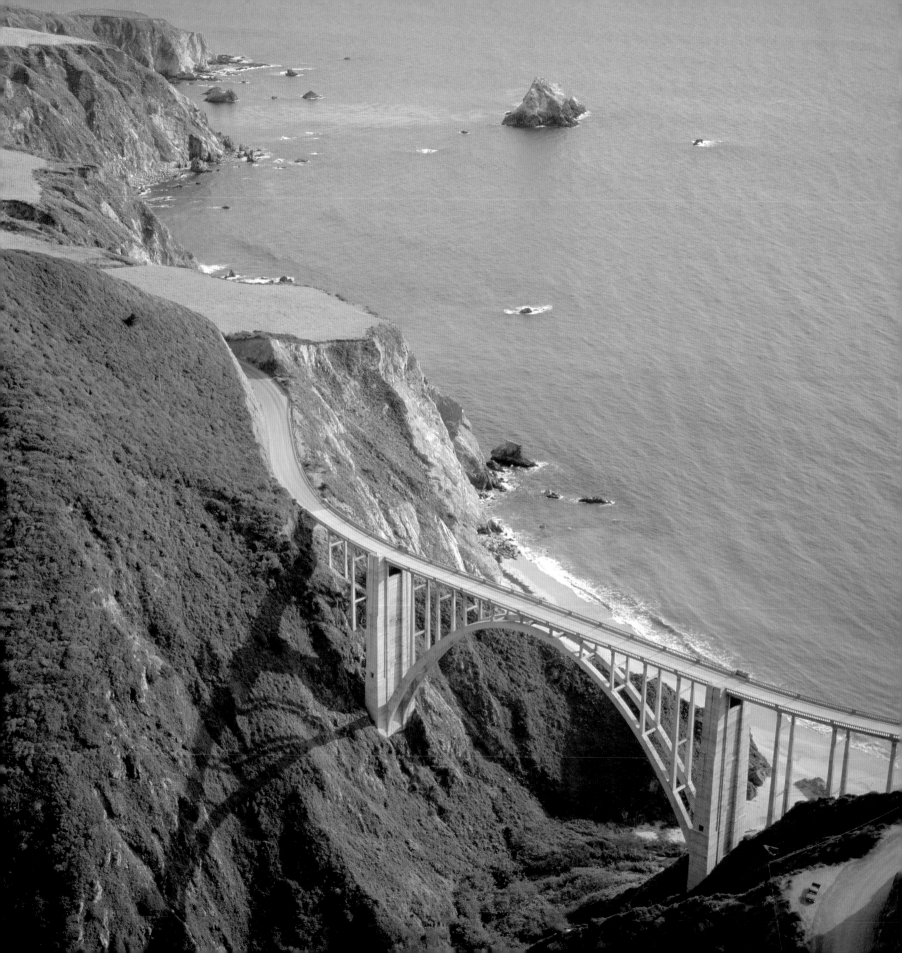

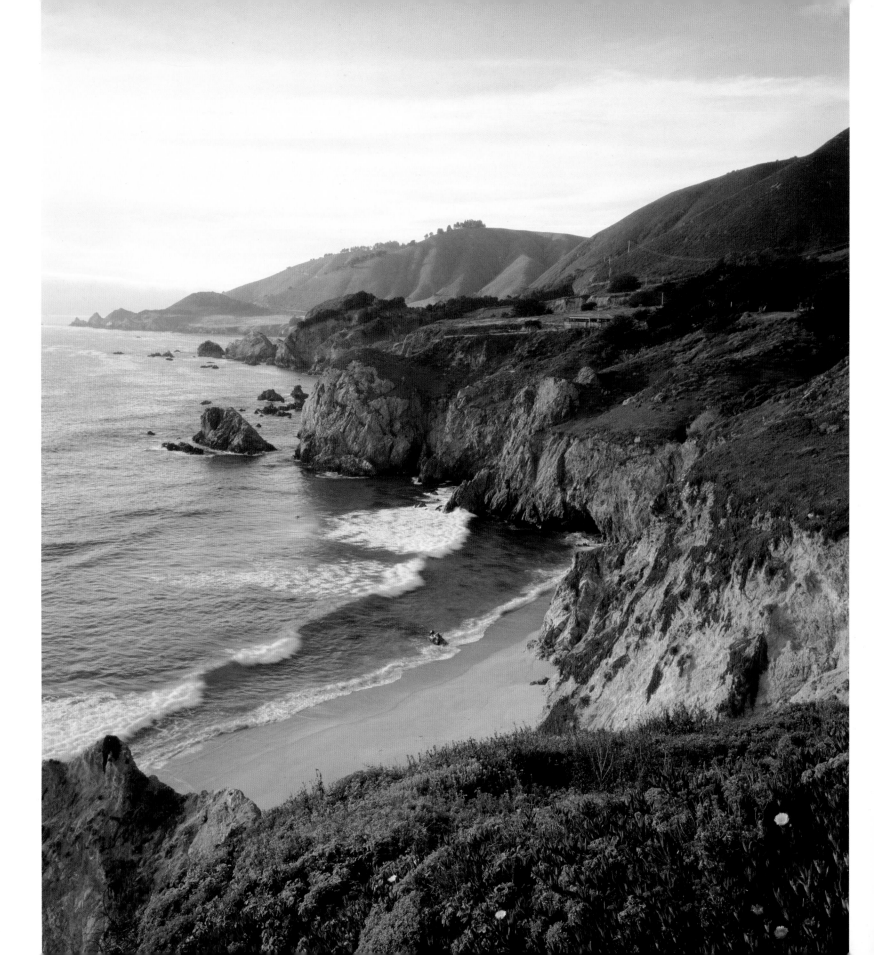

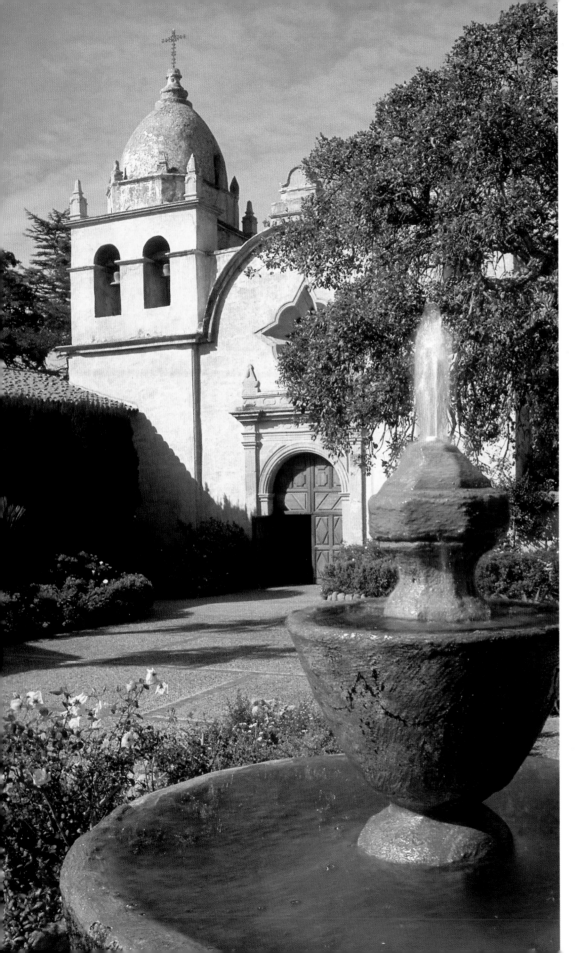

Mission San Carlos de Borroméo de Carmelo, founded at its present site in 1771, was once the headquarters for the entire California mission system. It is commonly known as the Carmel mission, and many consider it to be the most beautiful of all the California missions.

OPPOSITE PAGE: Big Sur is a rugged 90-mile stretch along one of the most breathtaking coasts in the world. It has no official boundaries, but the northern end is about 120 miles south of San Francisco and the southern end about 250 miles northwest of Los Angeles.

OPPOSITE PAGE: The scenic 17-Mile Drive passes opulent mansions and notable scenic spots, including the Lone Cypress Tree, the official symbol of Pebble Beach.

The 18th hole at Pebble Beach Golf Course on 17-Mile Drive. Pebble Beach hosts a variety of world-class golf tournaments.

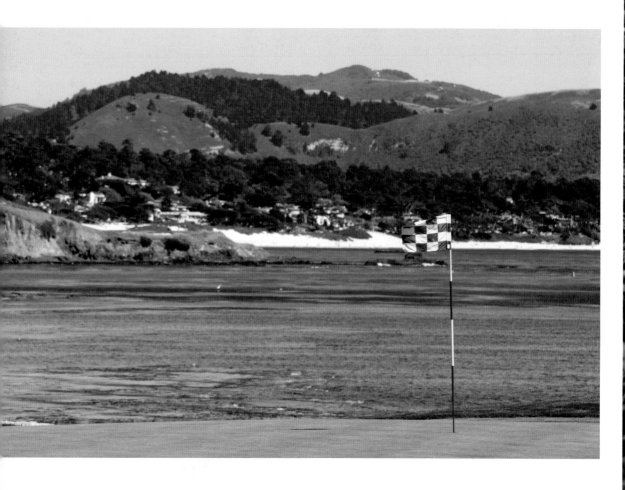

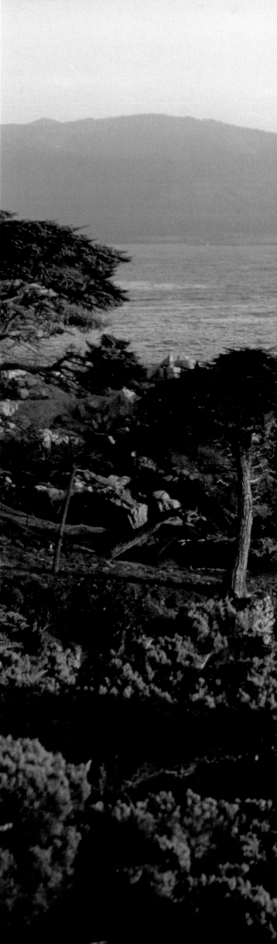

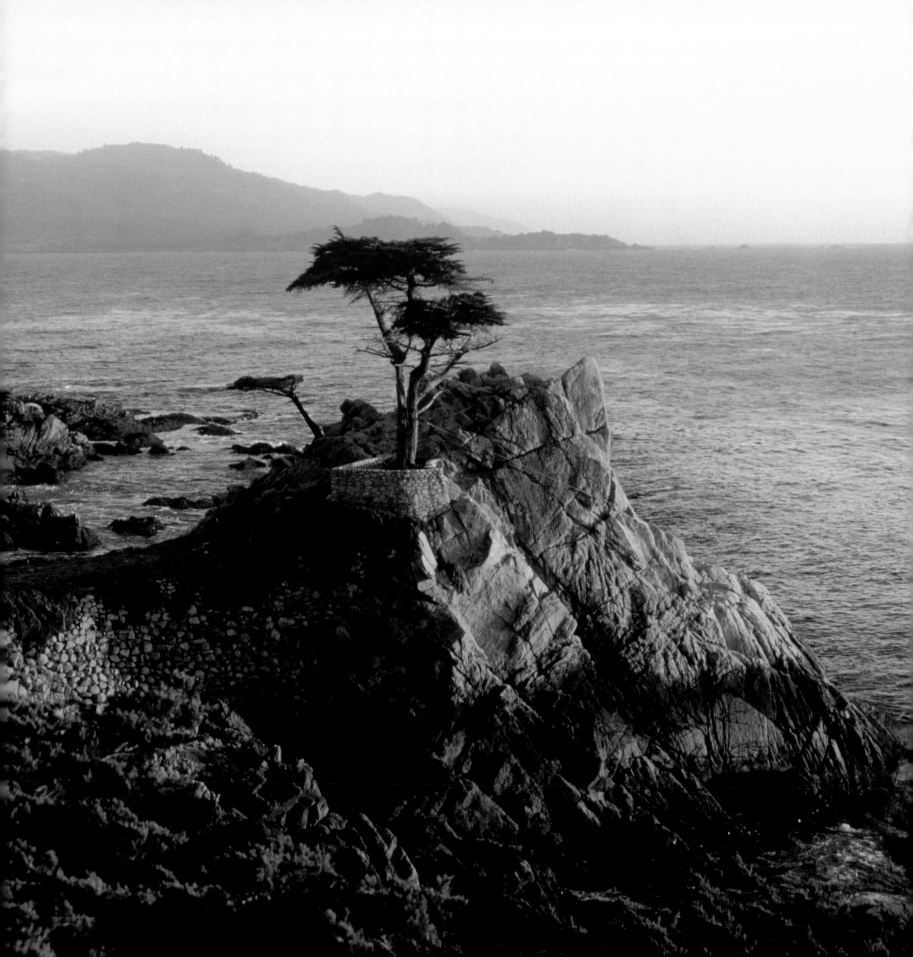

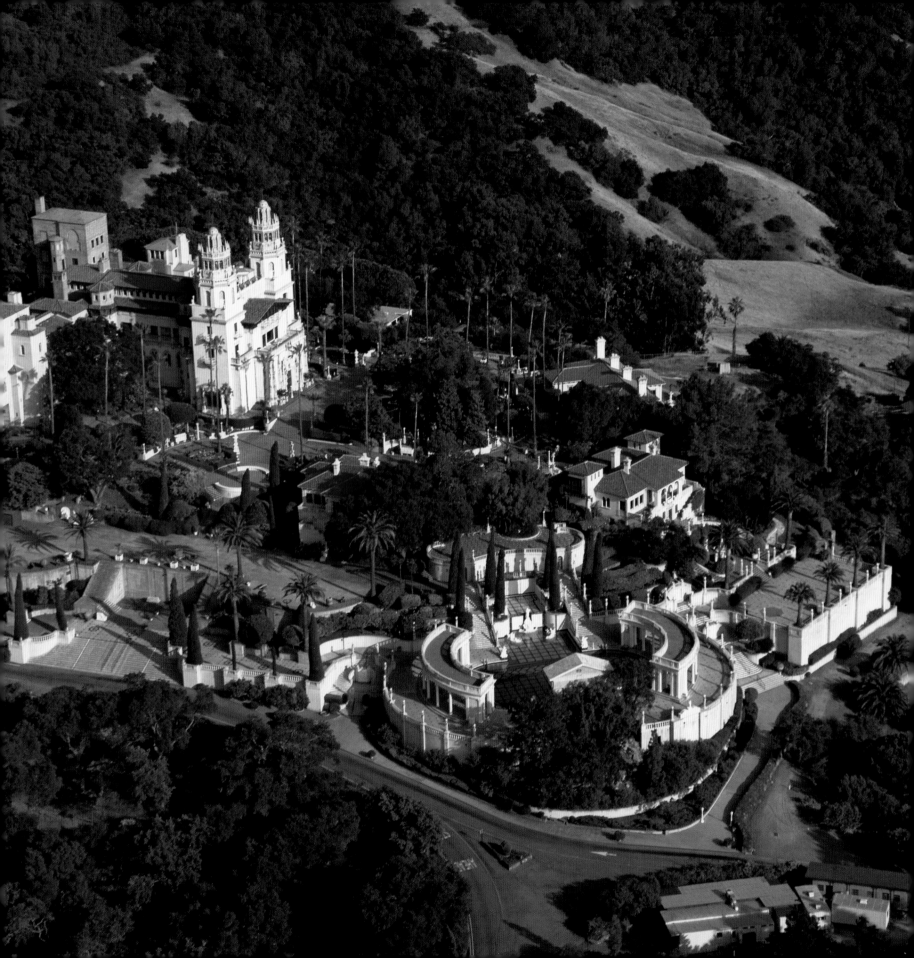

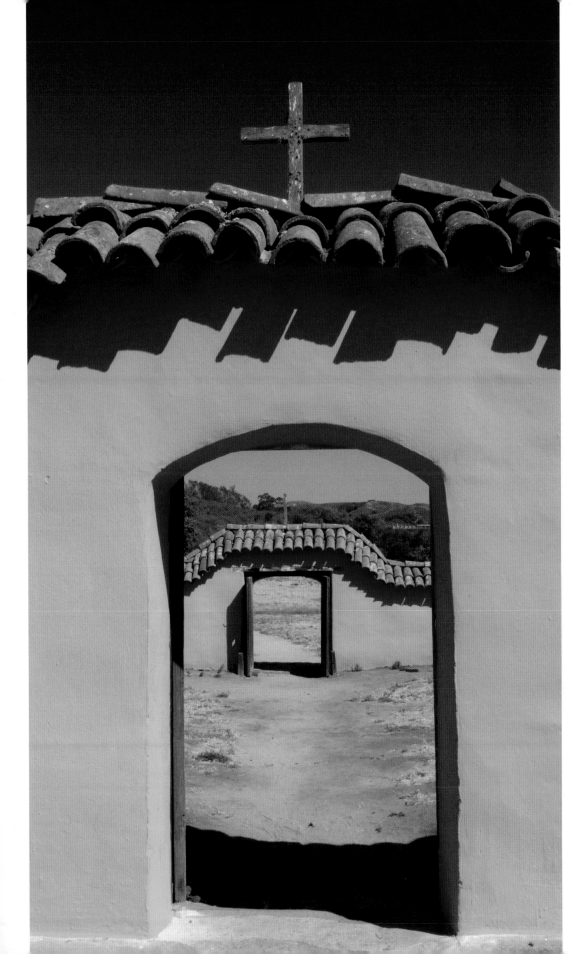

Mission la Purisima in Lompoc was founded in 1787 and destroyed by an earthquake 25 years later. Its restoration began in 1934, and today it is the most fully restored of all the California missions.

OPPOSITE PAGE: Hearst Castle, near San Simeon in South Central California, was built by newspaper tycoon William Randolph Hearst. The over-the-top estate is one of the world's great showplaces, combining various styles that impressed Hearst during his European travels. In its glory days, the castle included 56 bedrooms, 61 bathrooms, swimming pools, tennis courts, a movie theater, an airfield and the world's largest private zoo.

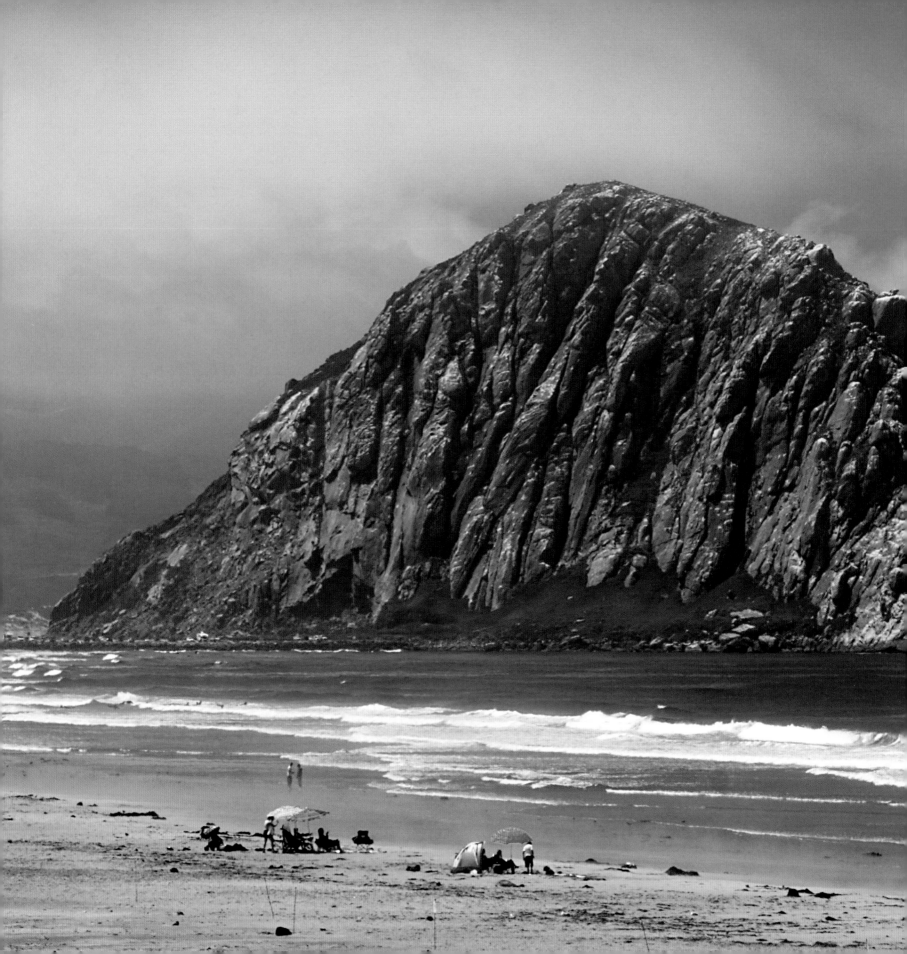

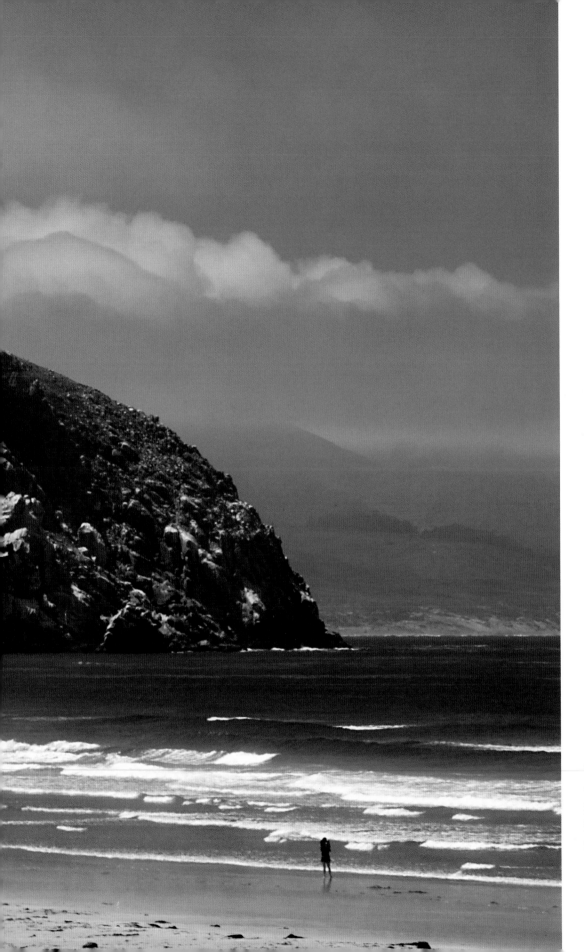

The dome-shaped Morro Rock is a dormant volcano that rises off the shore of Morro Bay. Sometimes called the Gibraltar of the Pacific, it has been designated a bird sanctuary for the peregrine falcon and other species.

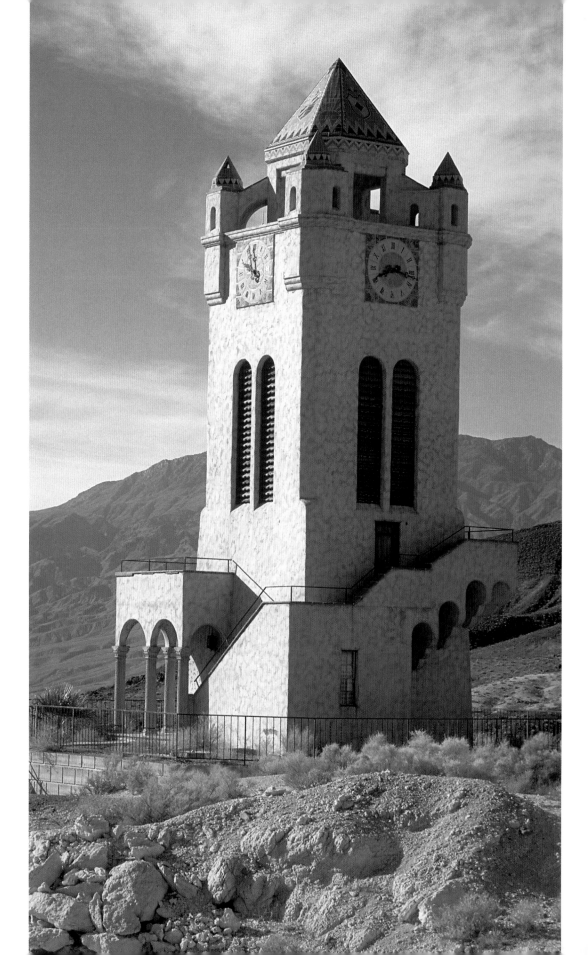

Scotty's Castle is an unexpected sight in the Death Valley area. It is named for the man who convinced a Chicago millionaire to invest in a local gold mine. The investment flopped, but the businessman was drawn to the dry climate of the desert. Built in the 1920s, the retreat covered more than 30,000 square feet and included this clock tower.

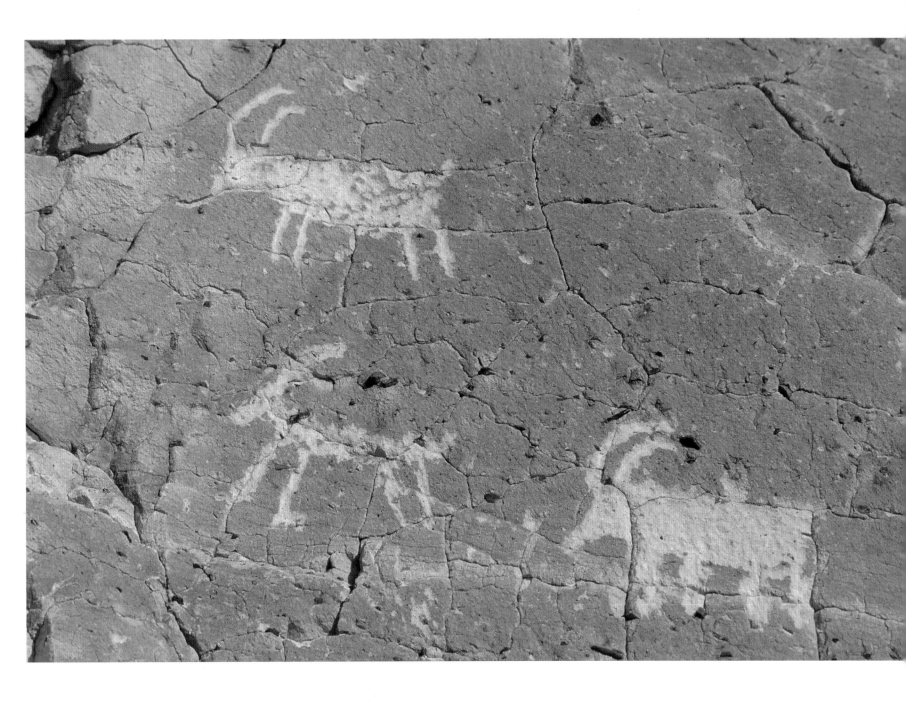

Examples of Indian rock art are located in Death Valley National Park. These depictions of bighorn sheep are likely to be Shoshone in origin and were found along Harrisburg Flats Road in the Panamint Range.

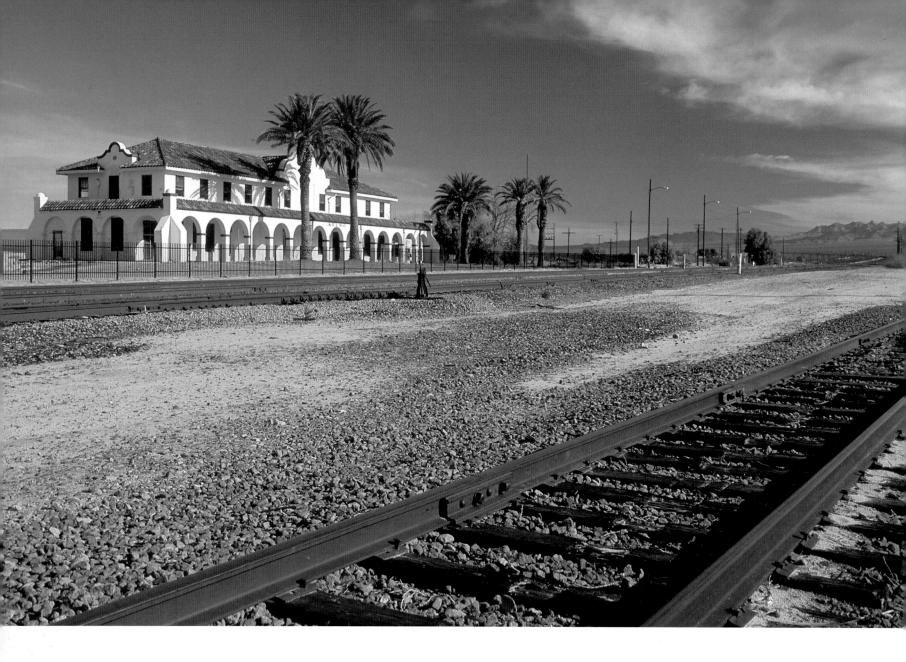

The town of Kelso was established in 1906, when the railroad was completed across the Mojave Desert. Today, the Kelso Depot is the Mojave National Preserve's principal information center. For many, it is a symbol of the West.

OPPOSITE PAGE: The sand dunes of Mesquite Flat, with their golden contours and shadings, are among the most photographed locations in Death Valley National Park.

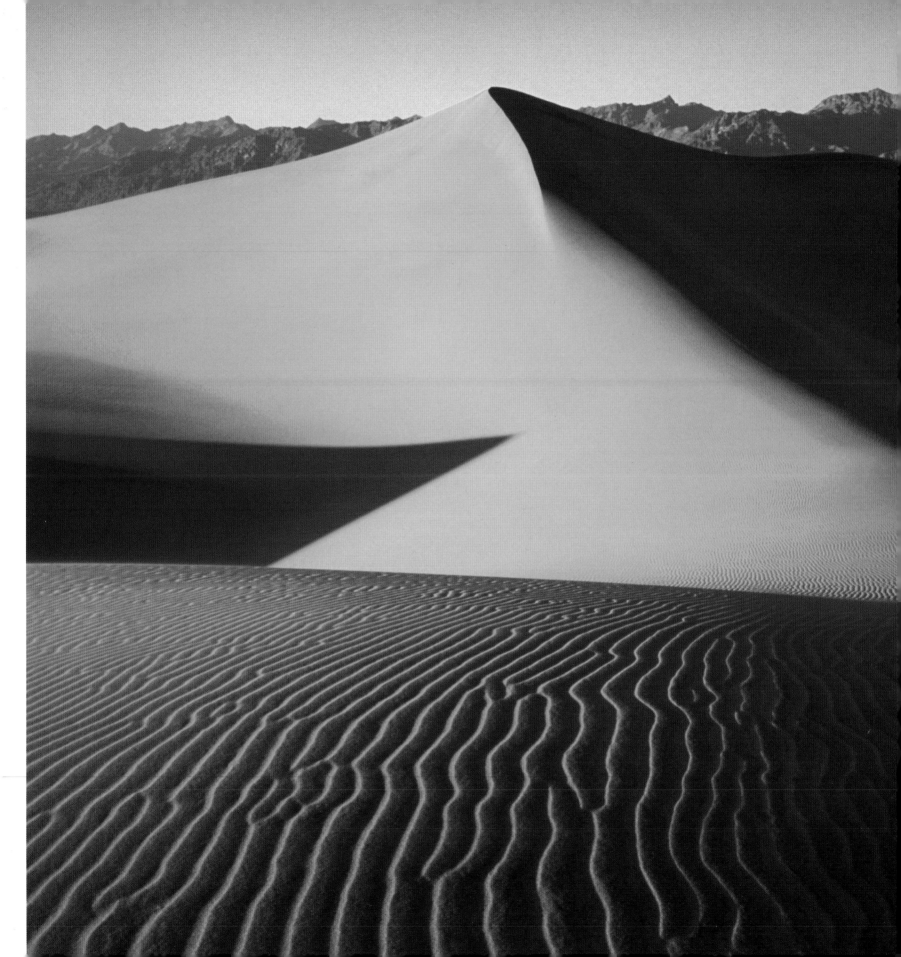

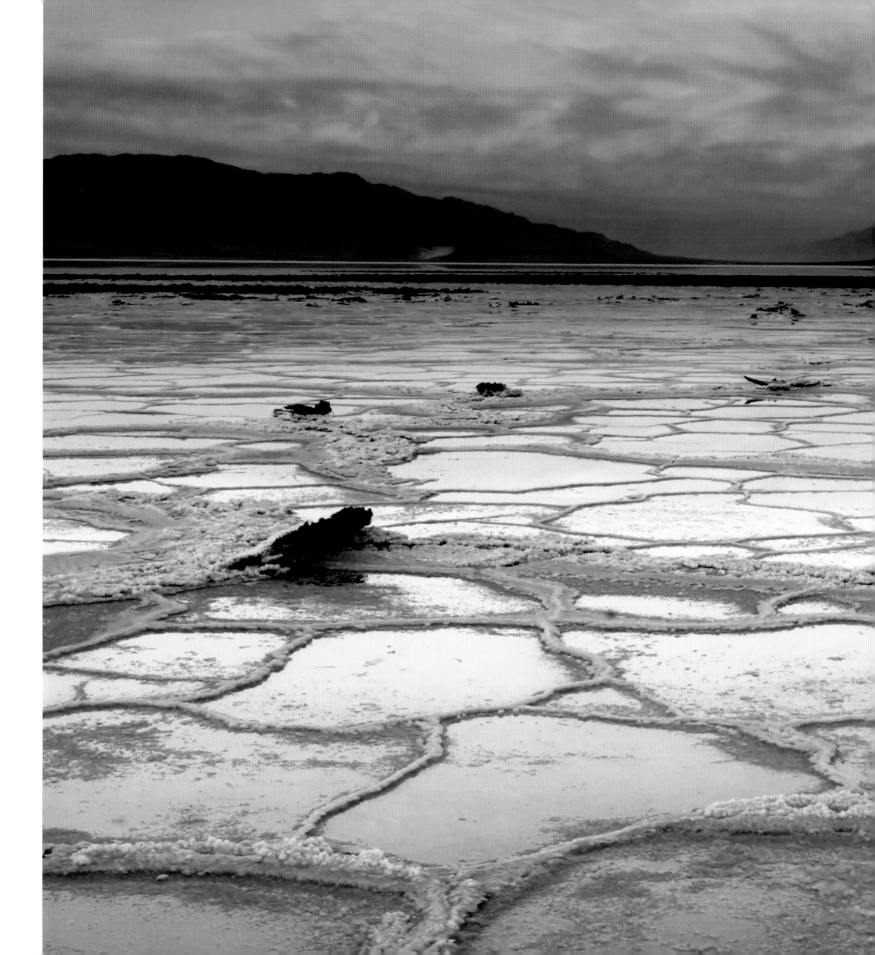

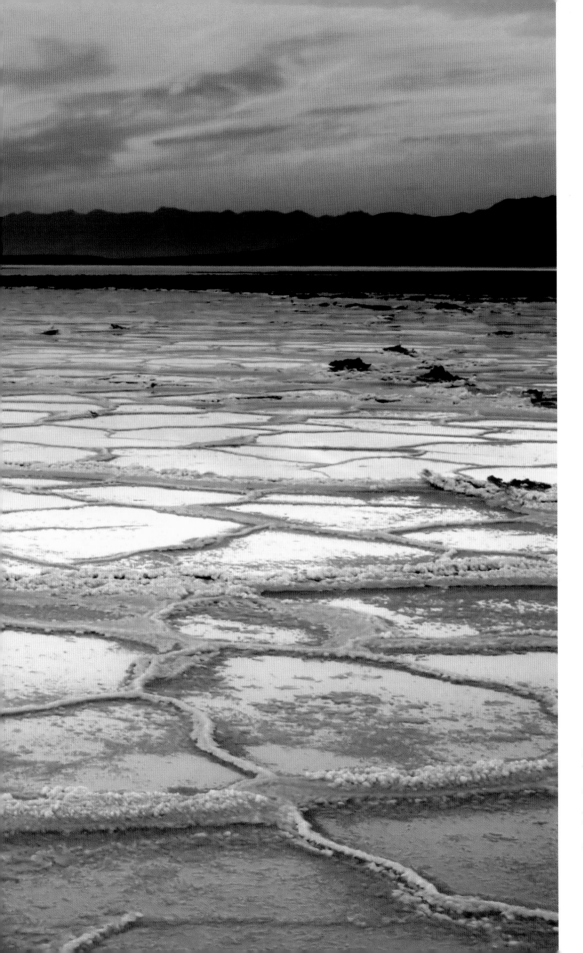

Sunrise over Badwater Salt Plain, Death Valley National Park. Badwater is a stretch of salt flats at the lowest point in North America – about 282 feet below sea level. The basin never dries out completely, and it even supports a species of fish.

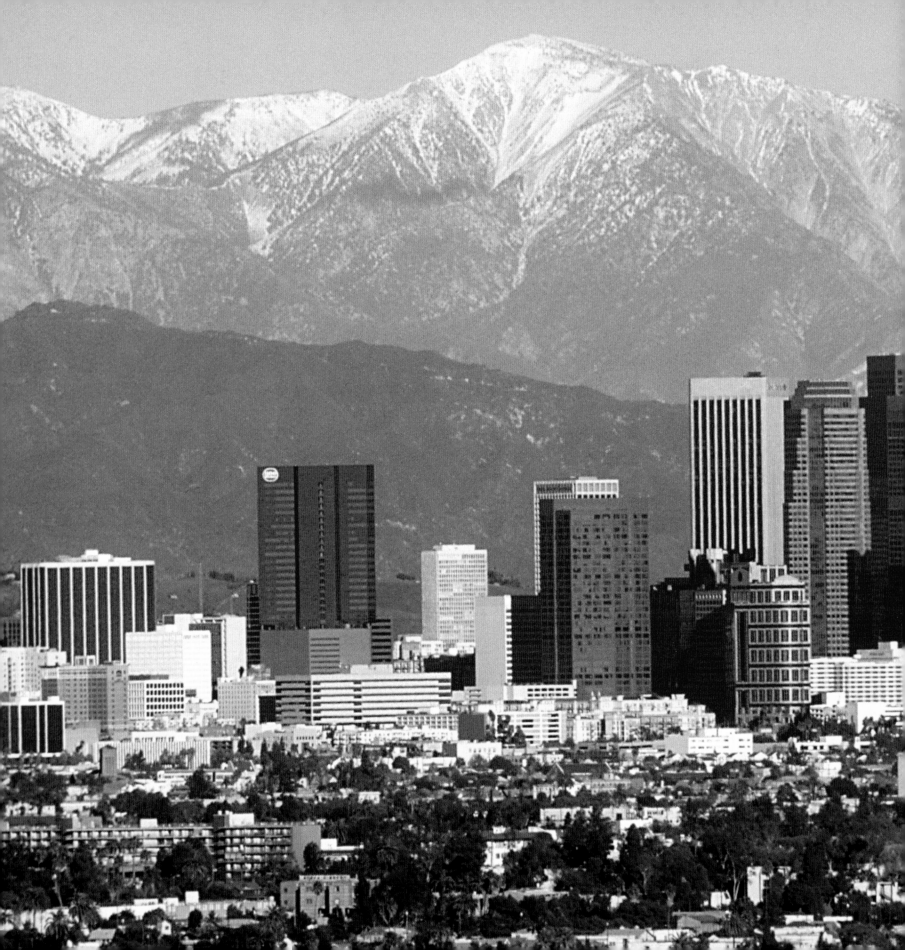

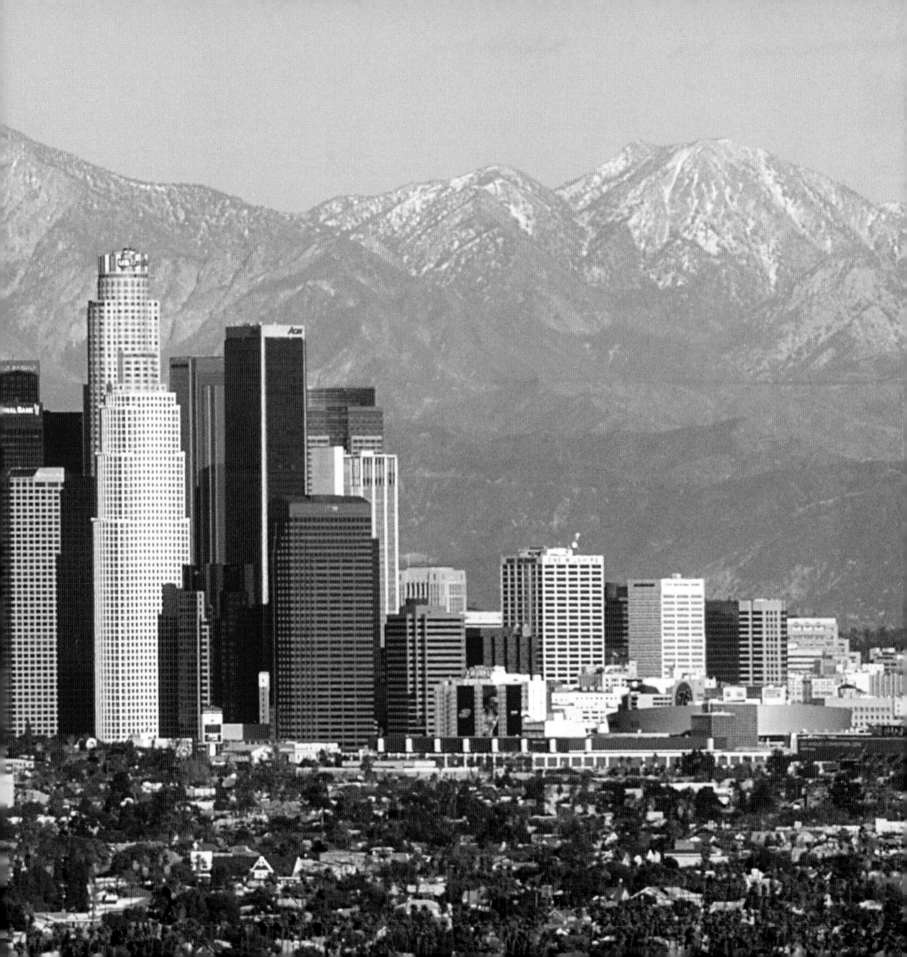

Marina del Rey is one of the world's largest manmade small-boat harbors. This unincorporated area of Los Angeles County features beach-style homes, restaurants and cafés.

PREVIOUS PAGE: The Los Angeles skyline, with the San Gabriel Mountains in the background.

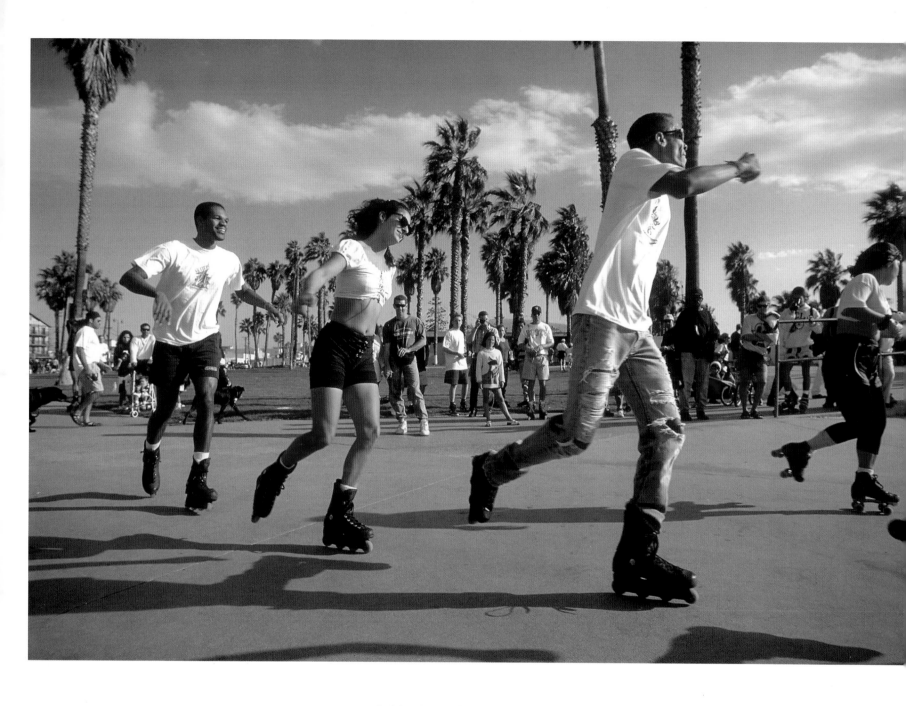

Venice Beach, like the city in Italy for which it is named, is known for canals. Its most famous feature is Ocean Front Walk, a lively parade of street performers, weightlifters, vendors and dance skaters.

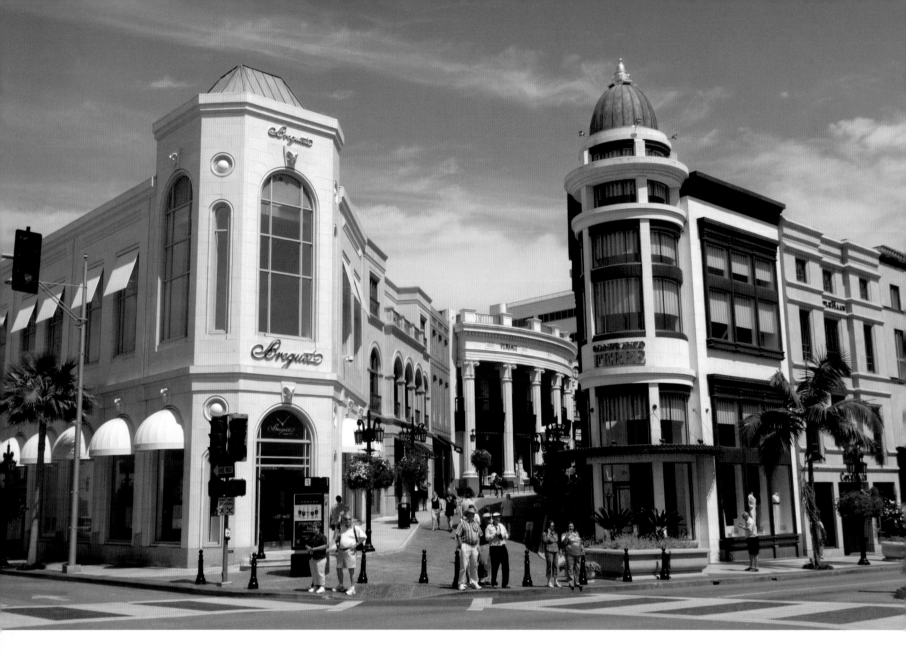

Rodeo Drive in Beverly Hills features three blocks of the world's most exclusive shopping. Its chic stores and upscale restaurants cater to the very wealthy, the very famous and the very curious.

OPPOSITE PAGE: Beverly Hills' city hall, designed in the Spanish Renaissance style and topped by a blue, green and gold tile dome, has been a landmark since 1932.

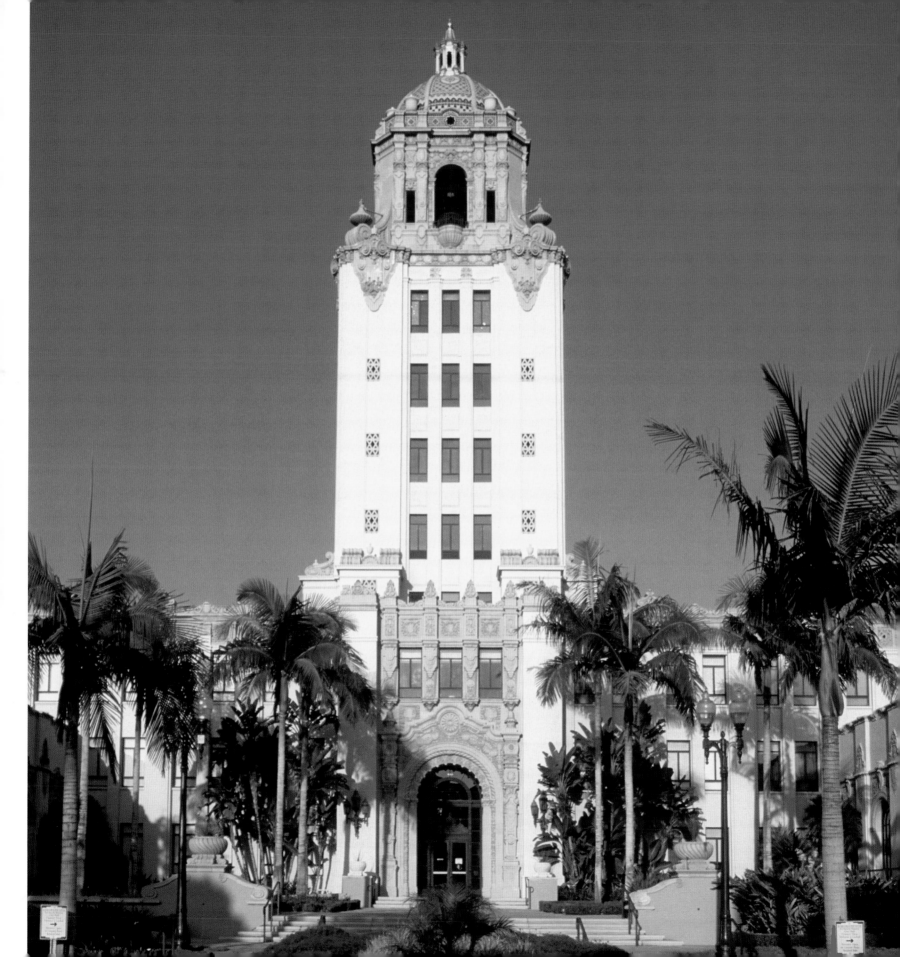

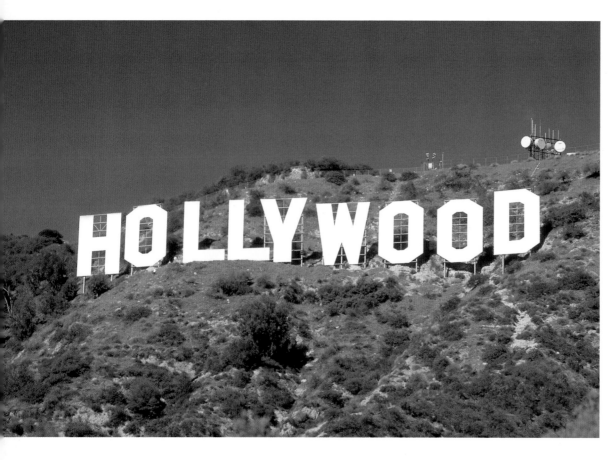

The Hollywood sign, positioned in the Hollywood Hills above Los Angeles, is an internationally recognized symbol of the movie business. Its 50-foot-high letters were originally created as an advertisement.

OPPOSITE PAGE: The iconic gates of Paramount Pictures recall an earlier era. Paramount is the only major classic studio still located in Hollywood. Tours include a behind-the-scenes look at the daily operations of a major motion picture and television facility.

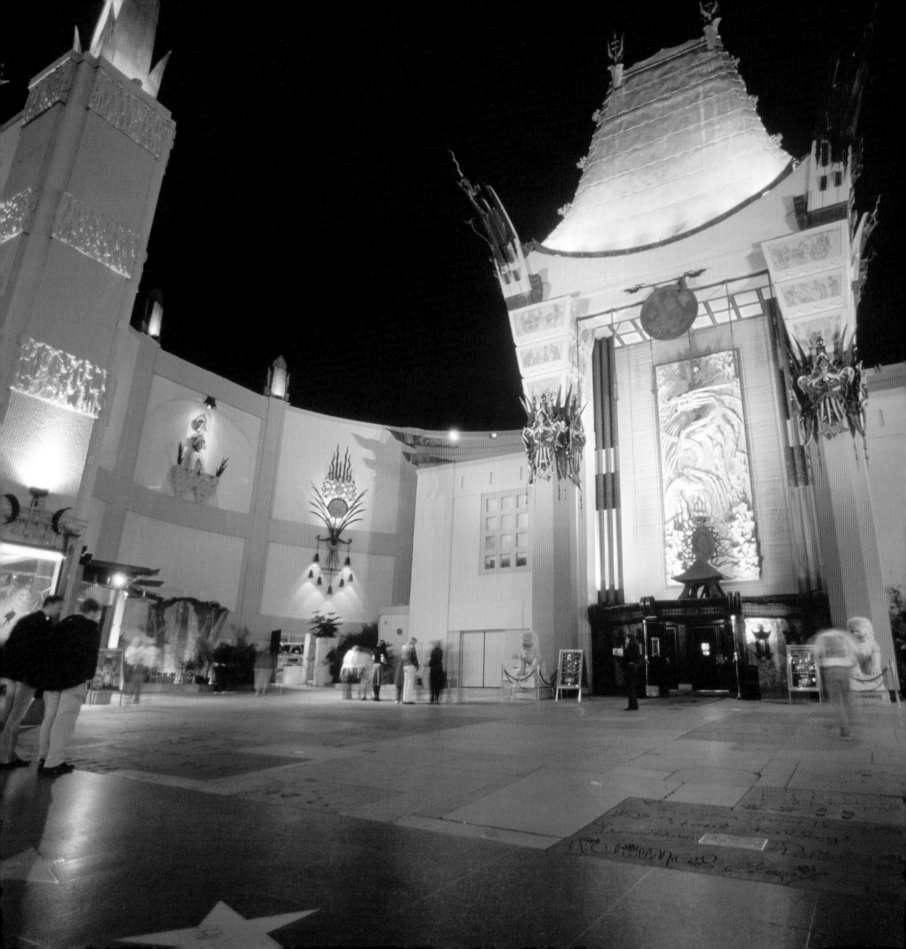

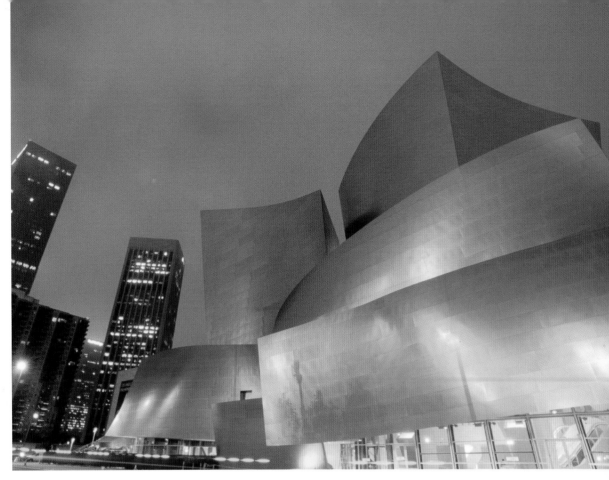

Walt Disney Concert Hall in downtown Los Angeles, designed by Frank Gehry, is home to the Los Angeles Philharmonic. Lillian Disney provided the initial funding as a gift to the people of the city. Considered one of the world's finest concert halls, it boasts outstanding acoustics.

OPPOSITE PAGE: Grauman's Chinese Theatre, on Hollywood Boulevard, has hosted many glitzy movie premieres. The concrete blocks in the forecourt bear the signatures, handprints and footprints of celebrities. The outside of the theater was designed to resemble a giant pagoda.

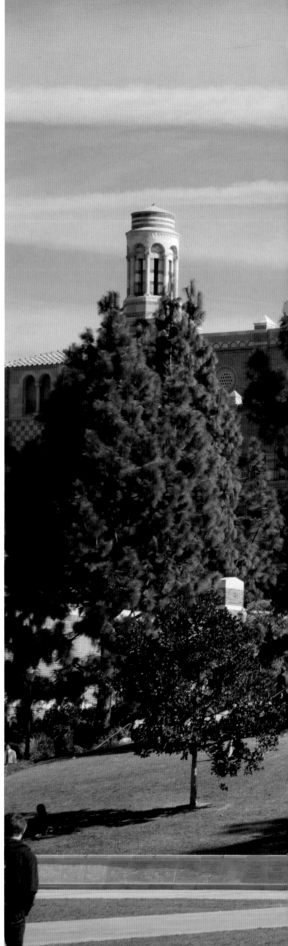

The Chateau Marmont Hotel on Sunset Boulevard is a reminder of an earlier era, when guests included the likes of Greta Garbo and Errol Flynn. Modeled after a castle in France, the historic landmark has survived numerous earthquakes, along with its share of scandals.

OPPOSITE PAGE: Royce Hall, on the campus of the University of California, Los Angeles (UCLA), was completed in 1929. It was modeled after a church in Milan and is distinguished for both its Romanesque style and its superb architecture.

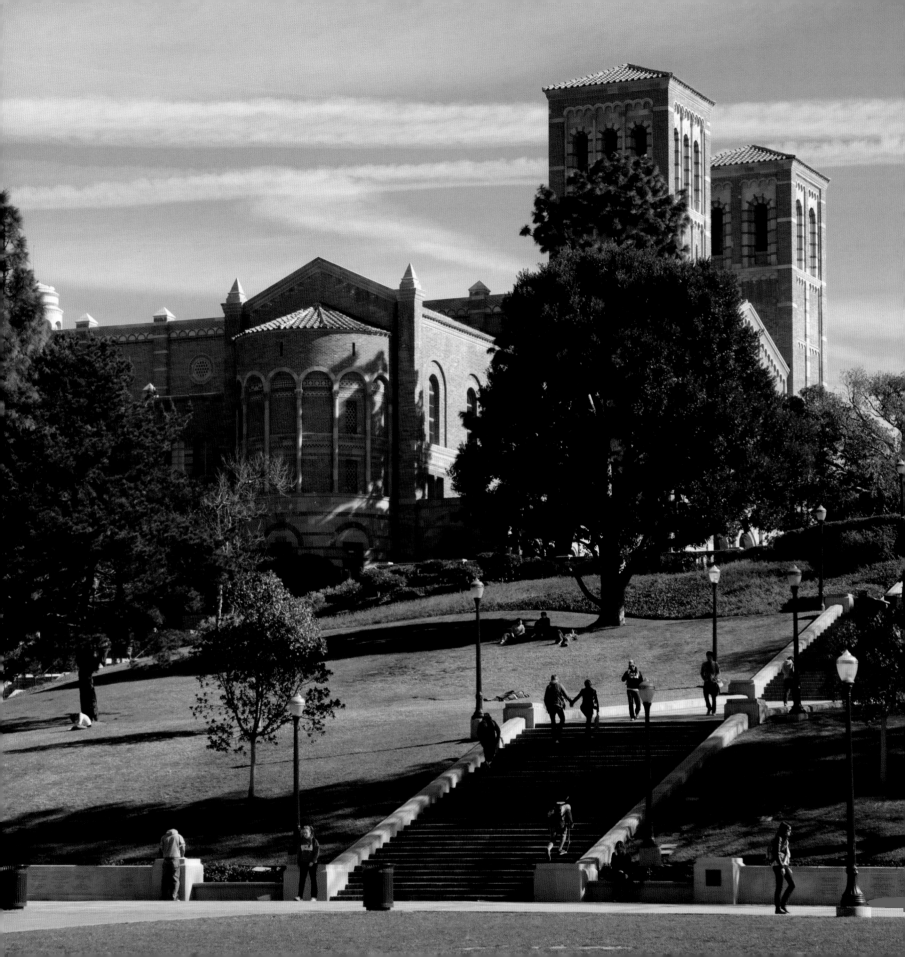

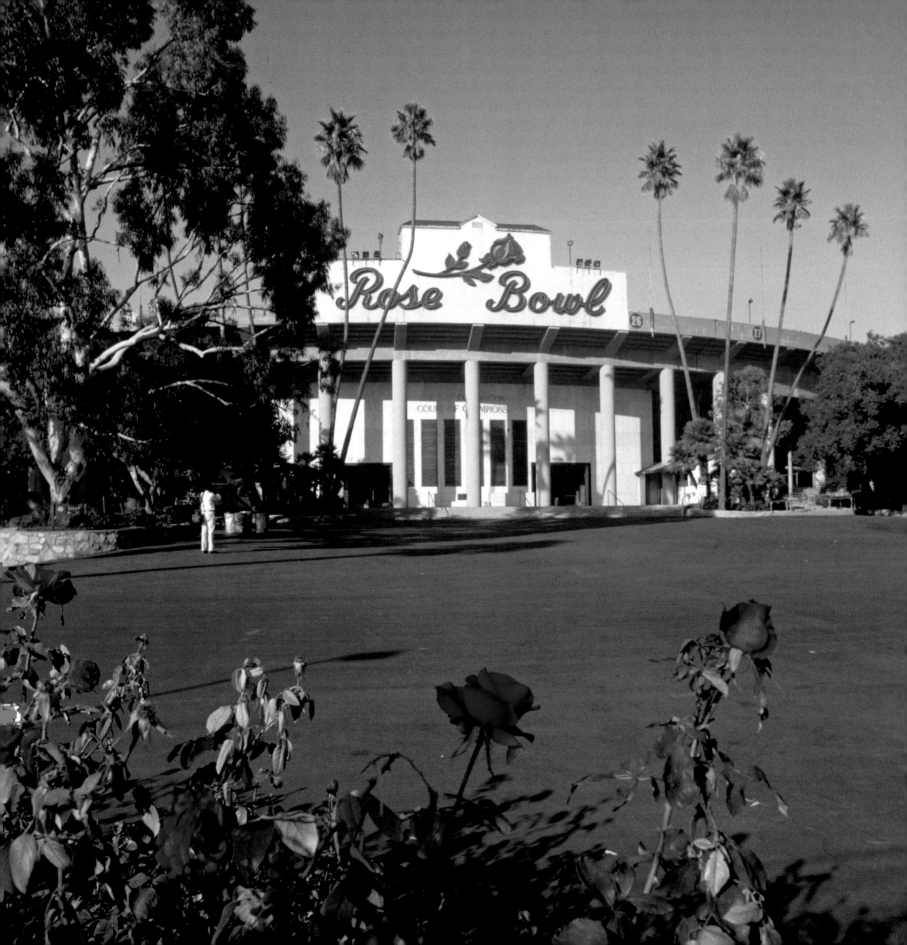

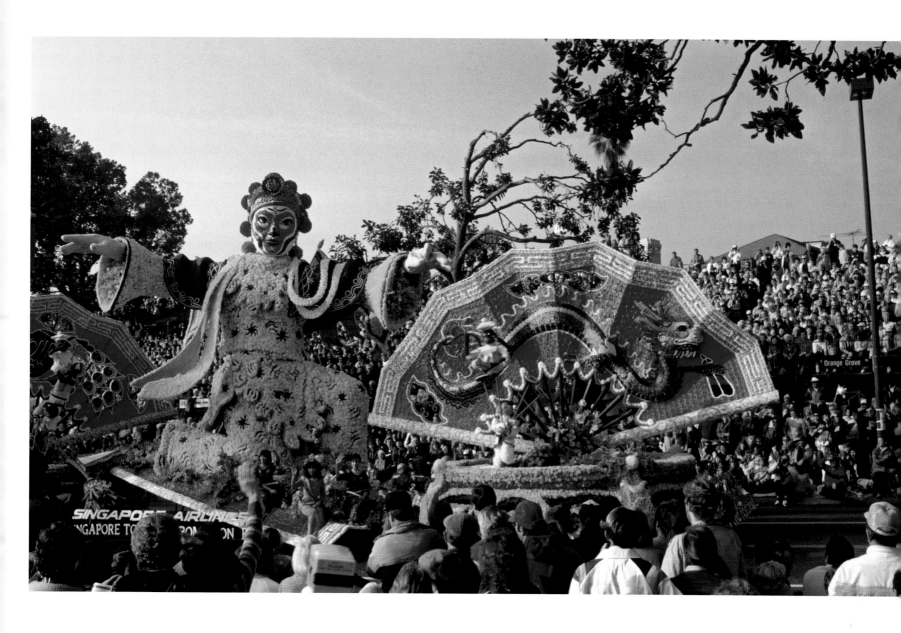

Every square inch of the exposed surface of a Rose Parade float must be covered with flowers or other natural materials.

OPPOSITE PAGE: Pasadena's Rose Bowl Stadium was built for the January 1, 1923, annual Rose Bowl football game. The Tournament of Roses Parade (also called the Rose Parade) is one of the most famous parades in the world and goes back to a late 19th-century festival with horse-drawn carriages.

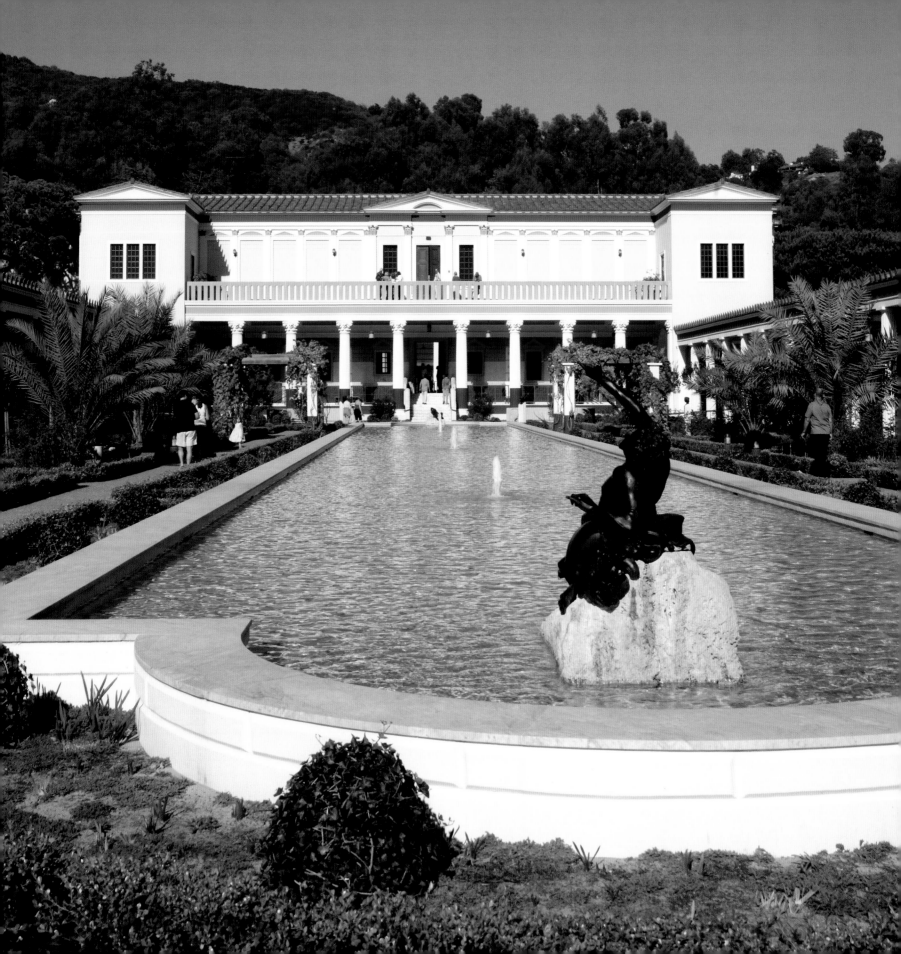

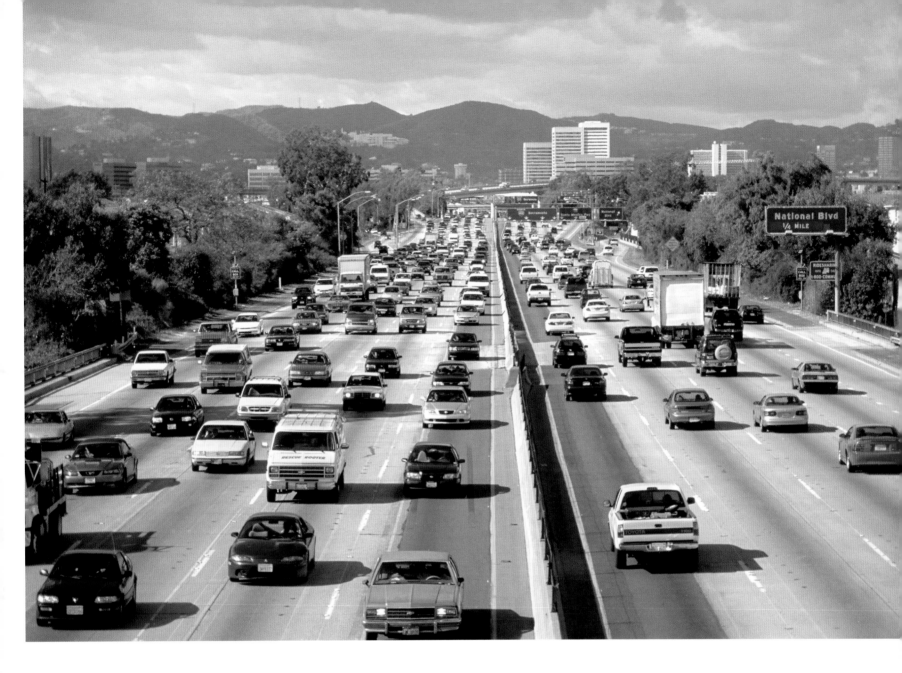

Los Angeles sprawls over nearly 500 square miles. It has more lanes per mile than any other freeway network in the world.

OPPOSITE PAGE: The Getty Villa, in Pacific Palisades, just outside of Malibu, is dedicated to the arts and cultures of ancient Greece, Rome and Etruria.

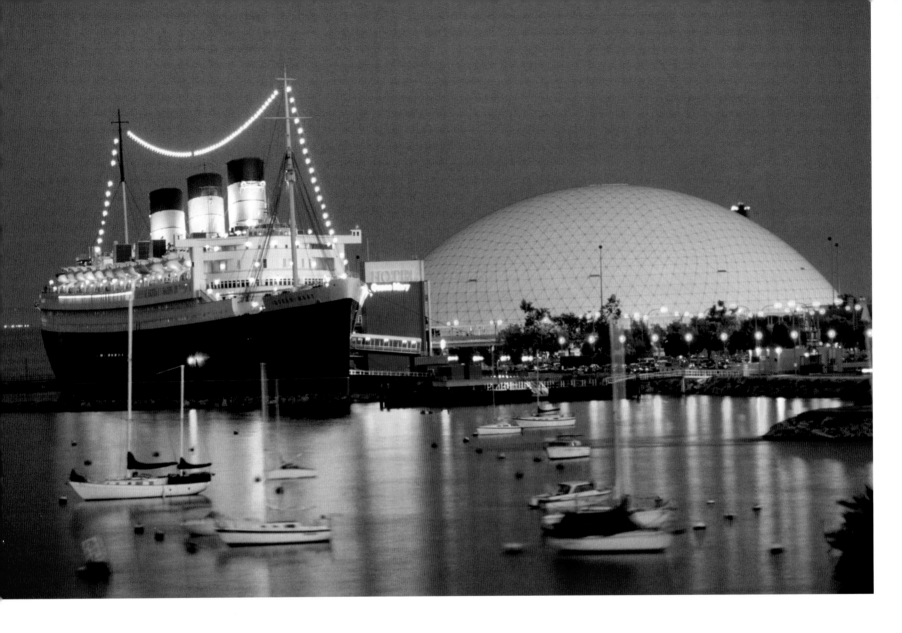

RMS *Queen Mary* is a retired ocean liner that is permanently docked in Long Beach Harbor. No luxury was spared during its years on the high seas. When it was retired, the grand ship steamed to Long Beach, where it is now a hotel and a tourist attraction, bringing alive the ghosts and legends of the great passenger liner.

OPPOSITE PAGE: Manhattan Beach in southwestern Los Angeles County is one of the country's most expensive coastal towns. It's popular for volleyball and surfing, and its 900-foot pier features the Roundhouse Aquarium.

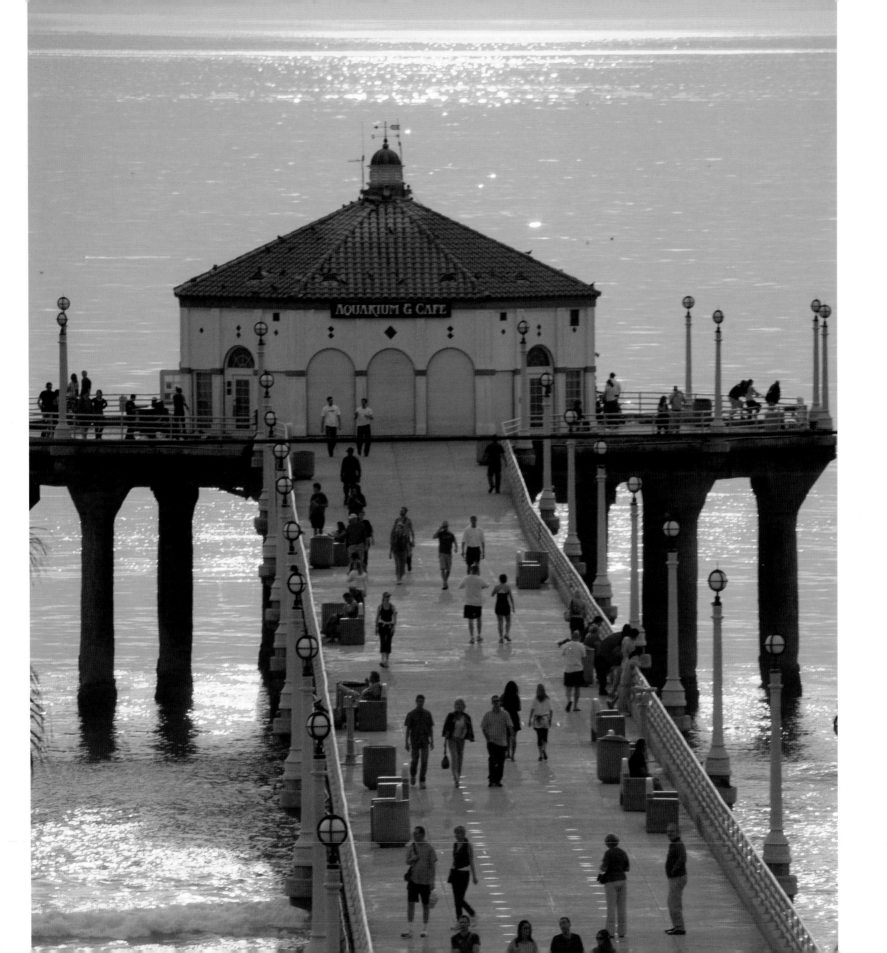

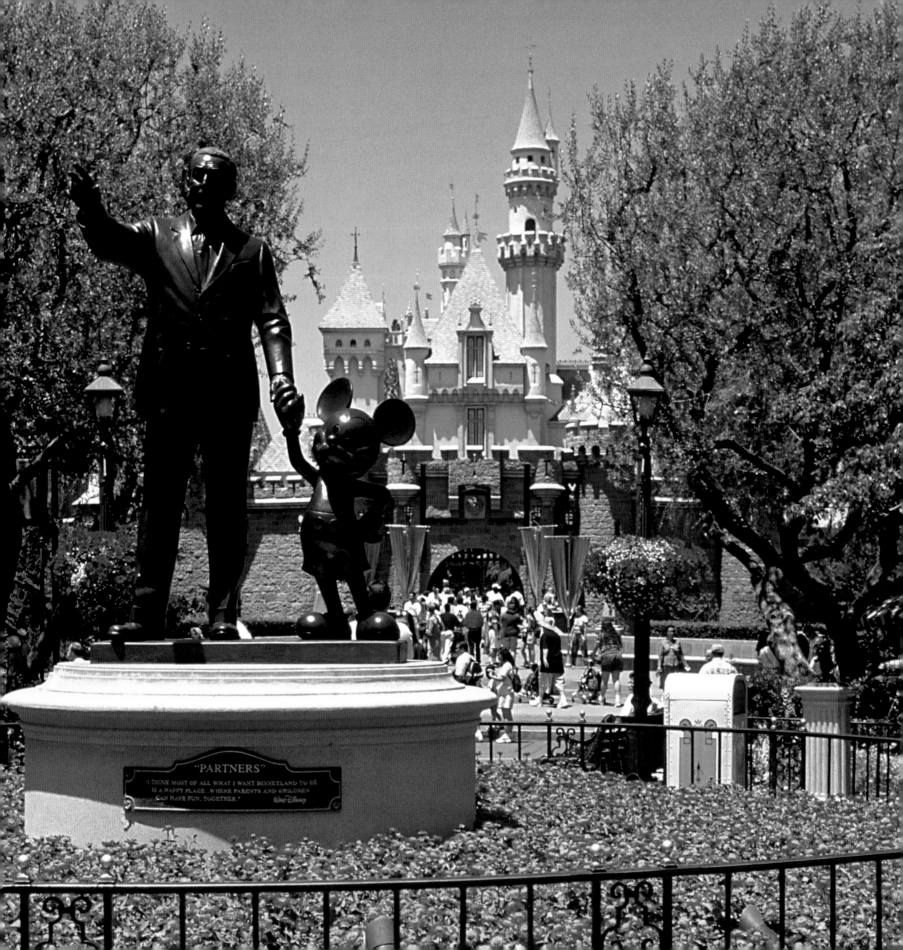

"PARTNERS"

"I THINK MOST OF ALL WHAT I WANT DISNEYLAND TO BE
IS A HAPPY PLACE...WHERE PARENTS AND CHILDREN
CAN HAVE FUN, TOGETHER."

Walt Disney

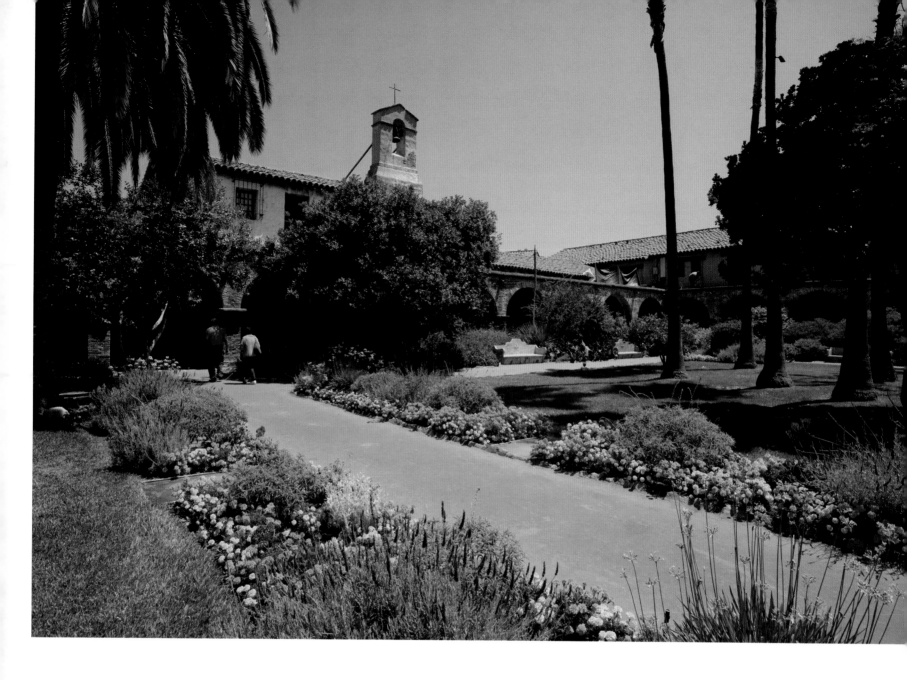

Mission San Juan Capistrano is known as the "Jewel of the Missions" and includes lavish gardens and fountains. The grounds are home to the swallows that return from their South American migration every year in March.

OPPOSITE PAGE: Disneyland Park in Anaheim opened in 1955 and has been visited by more than half a billion guests. It includes over 60 major attractions divided among eight lands, each with a theme. This statue stands at the end of Main Street USA, in front of the Sleeping Beauty Castle, and offers a welcome from Walt Disney: "I think most of all what I want Disneyland to be is a happy place … Where parents and children can have fun, together."

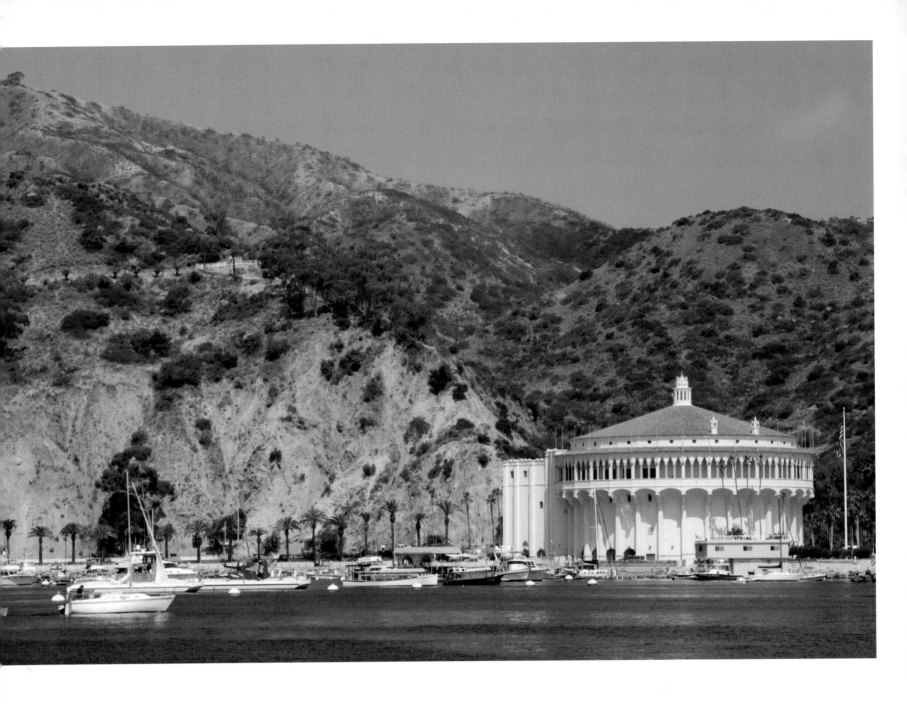

Santa Catalina Island, often simply called Catalina, is a rocky island off the Pacific coast that can be reached by ferry or helicopter. Cars are restricted, and the island is virtually smog-free. The Avalon casino building, once a popular spot for big bands, includes a museum on the ground floor.

OPPOSITE PAGE: Internationally known as Surf City, USA, Huntington Beach hosts special events and offers the largest stretch of continuous beachfront on the west coast.

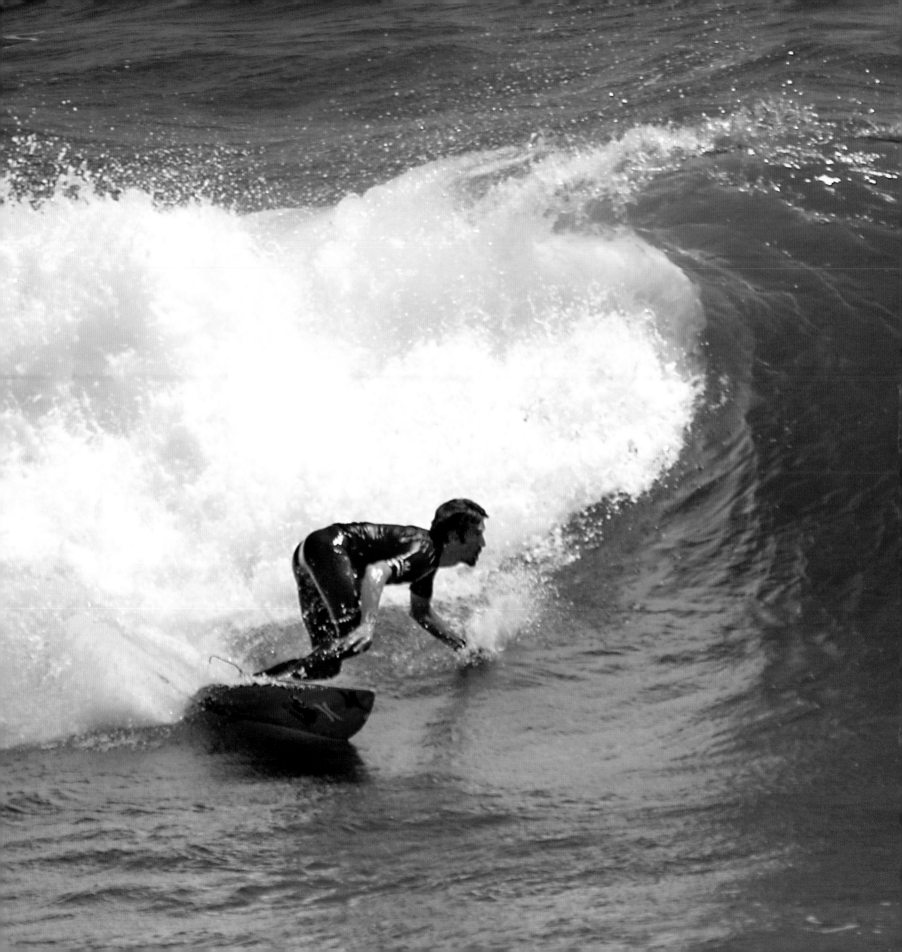

San Diego's Sunset Cliffs, popular with surfers and strollers, offers spectacular Pacific vistas. It's a splendid spot for watching the seasonal migration of California Grey Whales as they head southward to Mexico.

OPPOSITE PAGE: The legendary Hotel Del Coronado sits on Coronado Island, across the bay from San Diego. Built in 1888 and designated a National Historic Landmark, it has played host to celebrities and royalty.

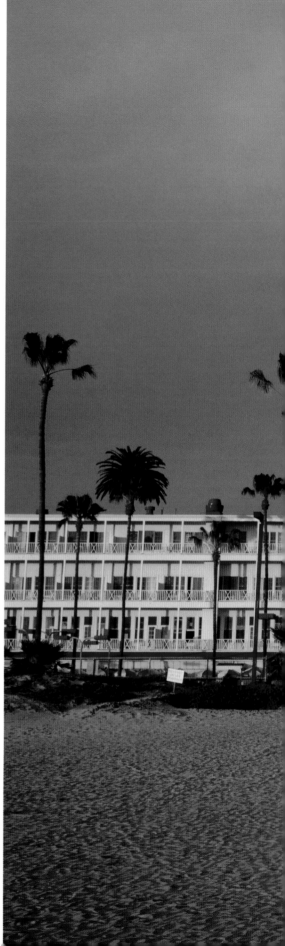

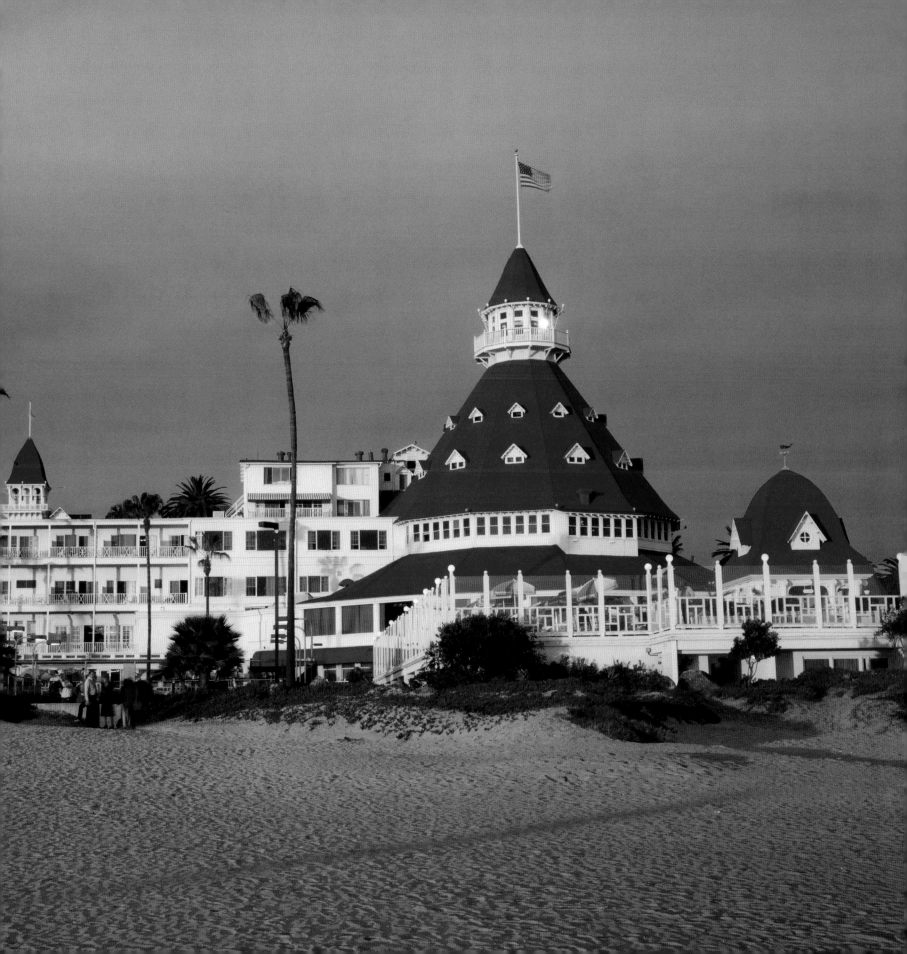

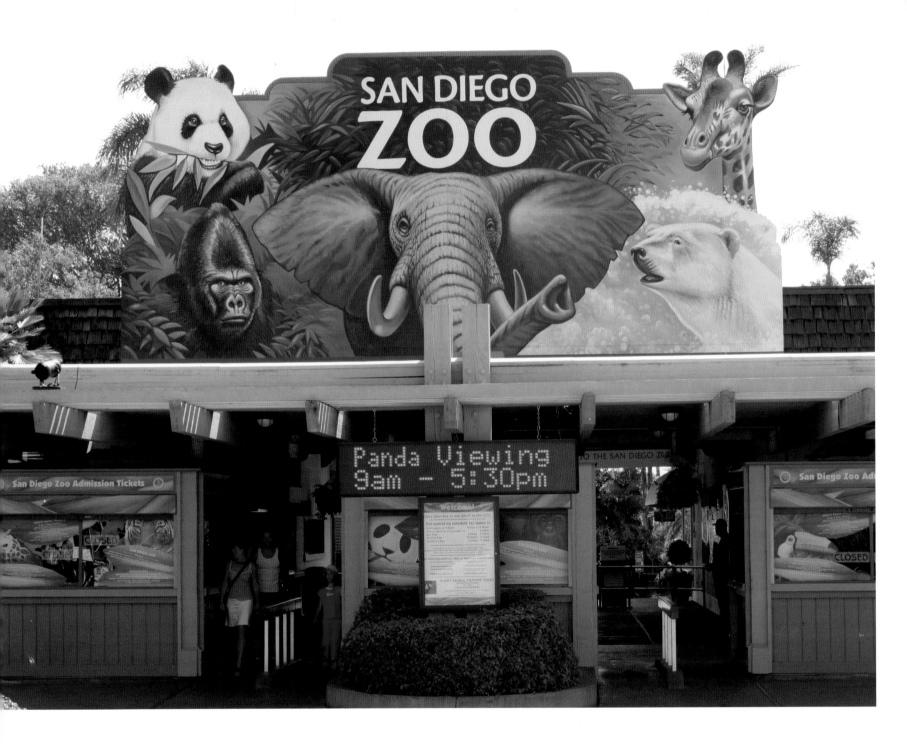

The San Diego Zoo is one of the largest and most progressive zoos in the world. It is home to more than four thousand animals and is one of very few zoos that house the giant panda (opposite page). Enclosures are set up to simulate the animals' natural environments. The zoo raises rare animal foods, including 40 varieties of bamboo for the pandas.

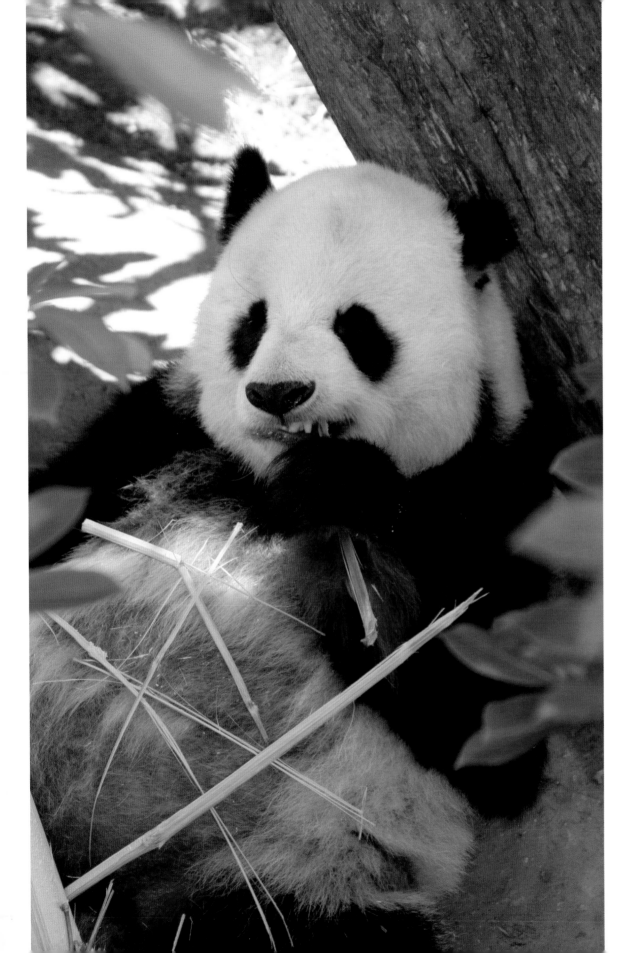

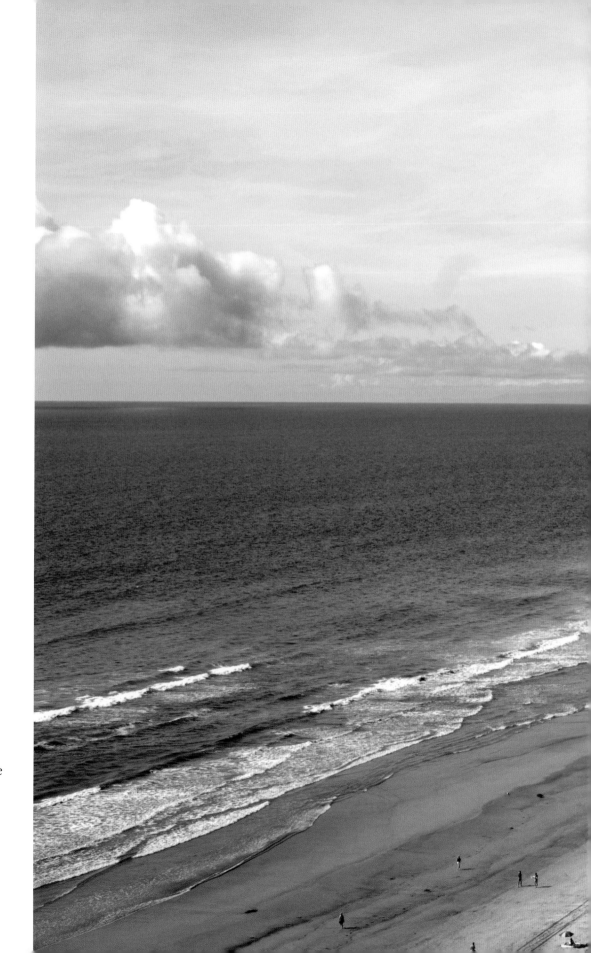

Hang gliders hover above Torrey Pines State Reserve and Beach as they look northward toward Solana Beach, one of the most beautiful beaches in San Diego County. Torrey pines are the rarest pine trees in the country.

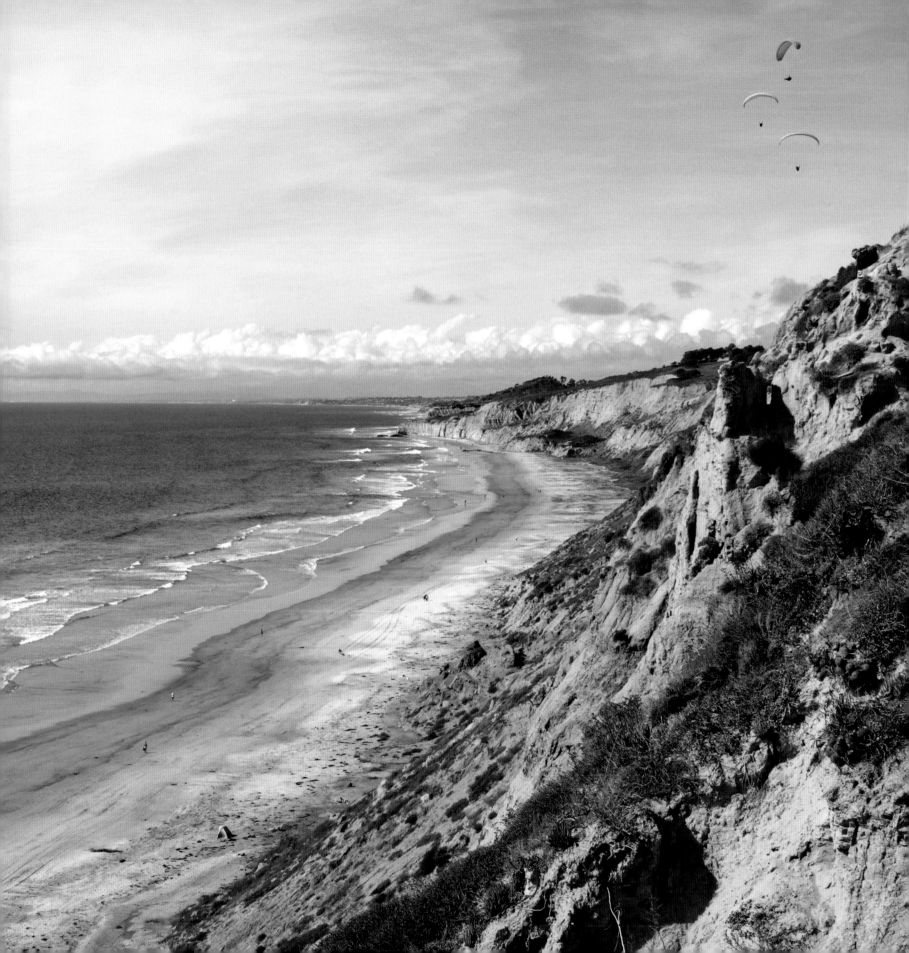

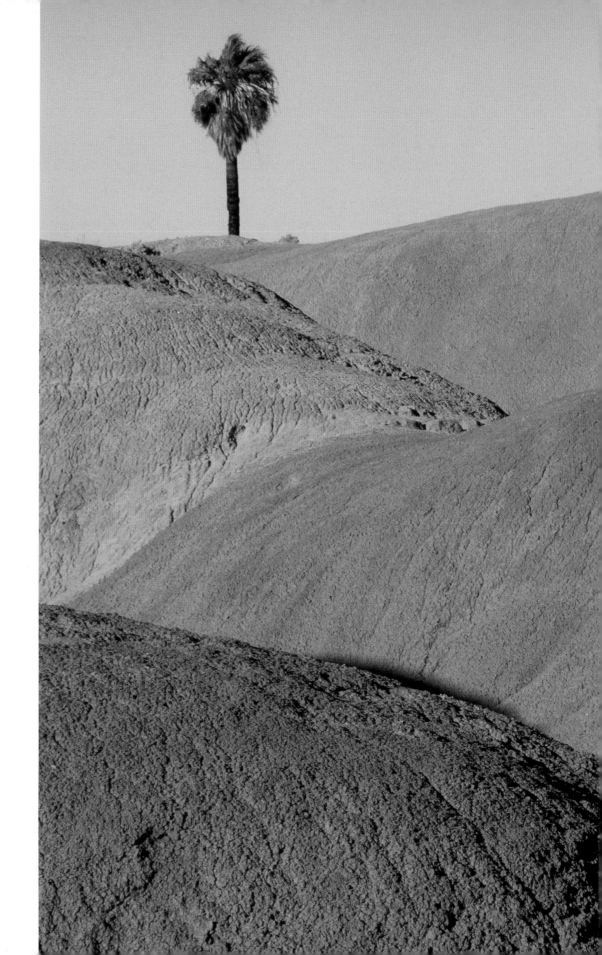

A lone palm tree in Una Palm Oasis,
Anza-Borrego Desert State Park.

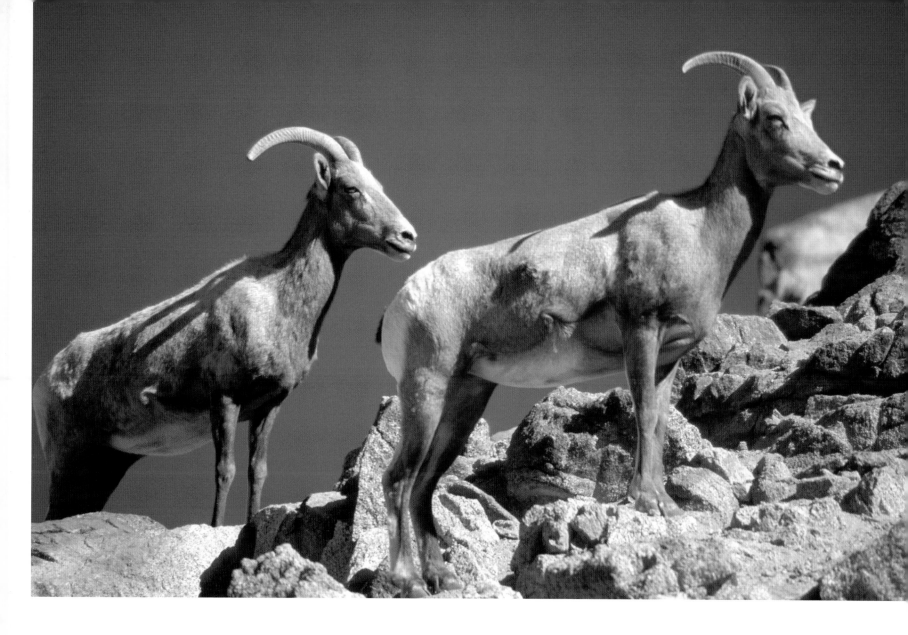

Desert bighorn sheep, in the Living Desert Wildlife and Botanical Park in Palm Desert, just outside of Palm Springs. Although their numbers have recently increased, the sheep's population remains extremely low. They are considered the desert's most beautiful animal.

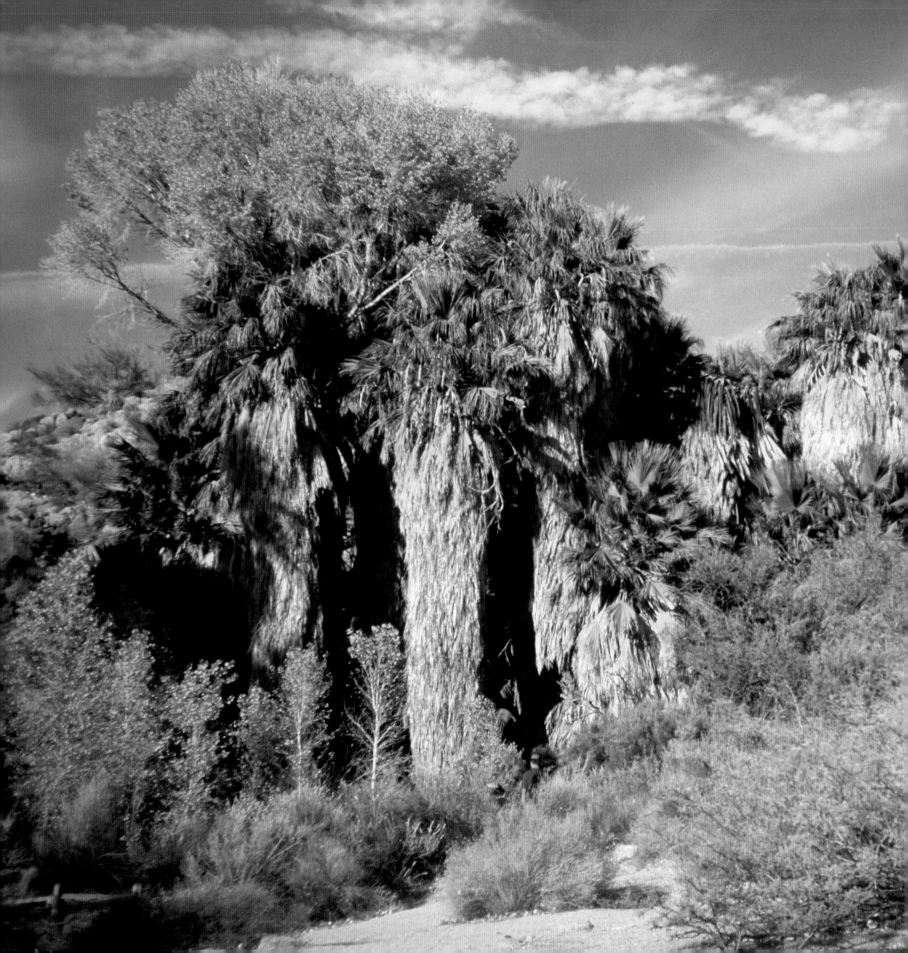

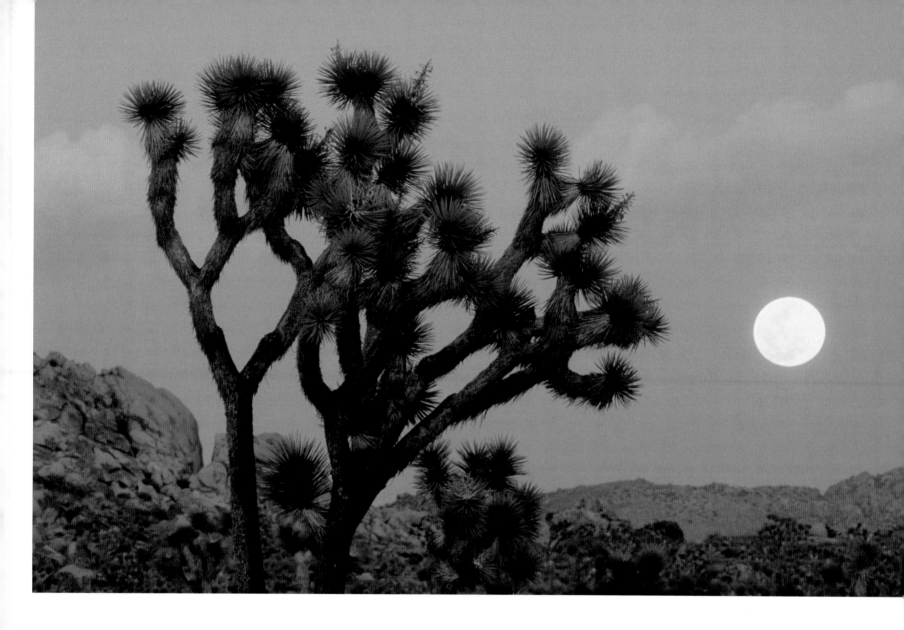

A Joshua Tree under a full moon in Joshua Tree National Park. Some observers have compared the tree to a Dr. Seuss–style illustration. The tree, whose name is derived from the Bible, can live for a thousand years.

OPPOSITE PAGE: Joshua Tree National Park is the habitat of a number of bizarrely shaped desert plants. Cottonwood Springs is one of the park's most scenic spots and the site of a fan palm oasis.

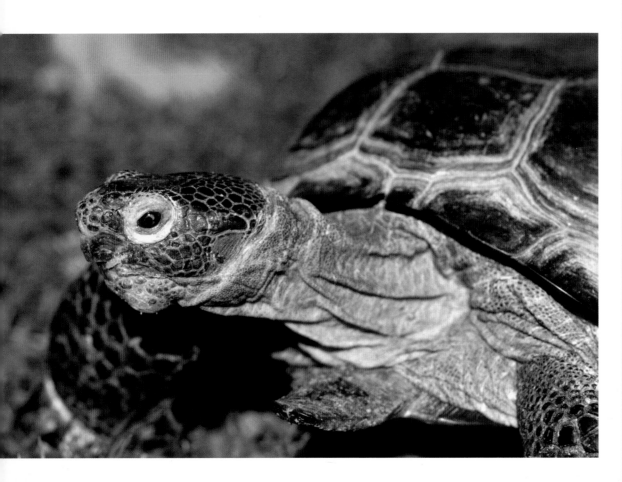

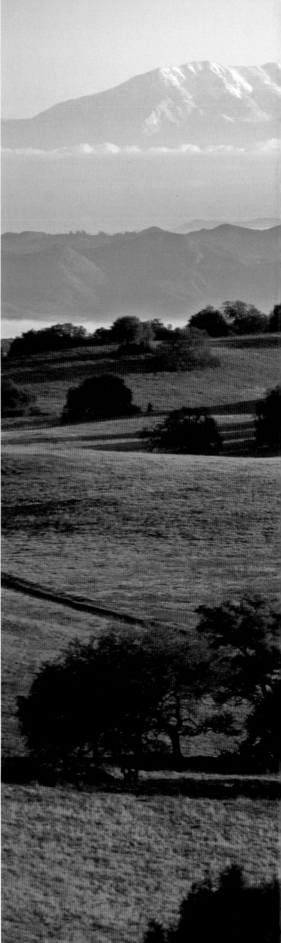

The desert tortoise is the largest reptile in the Mojave Desert. Known to live to one hundred years, it is listed as threatened under the U.S. *Endangered Species Act*.

OPPOSITE PAGE: The Santa Rosa Plateau Ecological Reserve at the southern end of the Santa Ana Mountains. The reserve is home to native plants that are becoming increasingly rare as the sprawling cities of Southern California continue to expand.